BASICS

CREATIVE PHOTOGRAPHY

Richard Salkeld

READING PHOTOGRAPHS

An Introduction the Theory
and Meaning of Images

Fairchild Books
An imprint of Bloomsbury Publishing Plc

50 Bedford Square 1385 Broadway
London New York
WC1B 3DP NY 10018
UK USA

www.bloomsbury.com

**Bloomsbury is a registered trade mark of
Bloomsbury Publishing Plc**

First published 2014

© Bloomsbury Publishing Plc 2014

British Library Cataloguing-in-Publication Data
A catalogue record for this book is available from
the British Library.

ISBN
PB: 978-2-9404-1189-4
ePDF: 978-2-9404-4761-9

Library of Congress Cataloging-in-Publication Data

Salkeld, Richard.
 Reading photographs / Richard Salkeld.
 pages cm
 Includes bibliographical references and index.
 ISBN 978-2-940411-89-4 (alk. paper) --
 ISBN 978-2-940447-61-9 (ePDF) 1. Photographic
 criticism. I. Title.
 TR187.S35 2013
 770--dc23

 2013021079

Cover Design: Bloomsbury Publishing
Book Design: an Atelier project, www.atelier.ie
Printed and bound in China

Title: Rainy Day Woman #3, 2012
Photographer: Richard Salkeld

Reading a photograph is often so instant that we are barely conscious that it is a process at all. But reading is an active and creative process of interpretation in which we draw on our own experience, knowledge and imagination. This image doesn't release all its information directly and so slows down the process, prompting questions and speculation. It is a 'found' image: a photographed detail of a photocopied notice exposed to rain. The accidental textures and colours enter into the imagined story of this unknown woman.

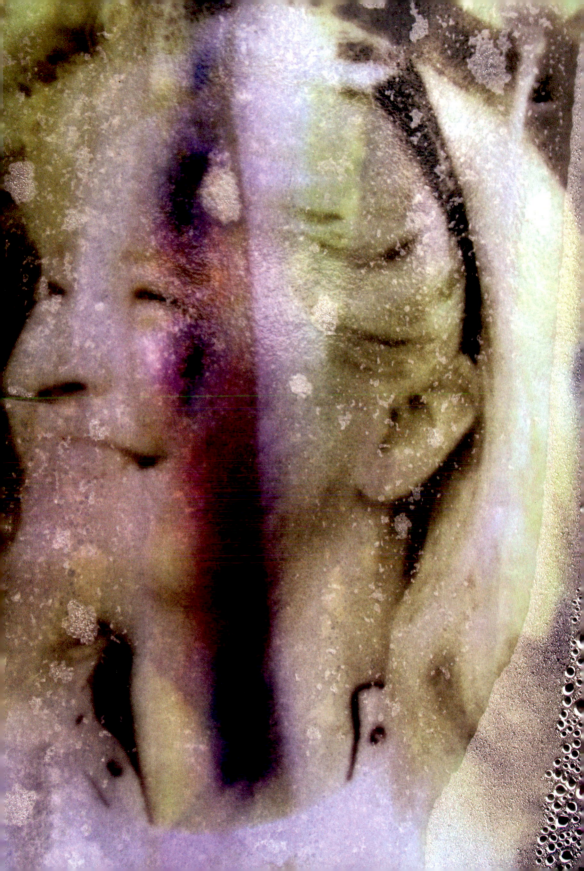

Introduction 6

Contents

4

5

6

Imagine a world without photography: no news photographs, no advertising photographs, no family photographs, no endless supply of illustrated magazines. Imagine the Internet without photographs! How would our knowledge and understanding of the world be different? How would culture be different? How would we be different?

This book sets out to examine how photography affects us all: how it helps to shape our knowledge of the world, our culture and ourselves. Through a close reading of images, theories of representation, identity and visual analysis will be explored and explained. The ethical issues associated with the practice of photography, and the representation of people and ideas, will also be discussed.

It is almost as hard to imagine a world without photographs as it is to grasp just how many photographs now exist. For the best part of 200 years the world has seen an ever-increasing rate of production that has been further accelerated by the advent of digital photography. At the time of writing it is estimated that, on average, more than a million images are uploaded to Flickr every day, and that the total has exceeded six billion. It is estimated that more than 100 billion have been uploaded to Facebook! In short, we live in an image-saturated environment, and it is clear that photographs have a major role to play in human communications.

Magic and myth

Despite the mind-boggling number of images in the world, paradoxically, most photography is 'invisible' – that is, we see what a photograph 'shows' but we don't see the photograph as a 'thing'.

Most photographs exist to inform, record, illustrate: simply to show and tell. Most of these we can instantly comprehend: to understand them seems to require no greater skill than opening our eyes and looking. Indeed, looking at most photographs we generally suspend our consciousness of looking at a representation at all and put ourselves into the position of the photographer looking directly at the scene in front of the camera's lens. This is the magic (and the myth) of photography: it is a medium that seduces us into thinking that it is not a medium at all, that it is really a direct conduit to reality.

Much of the photography in the world is made, apparently, without any special skill on the part of the photographer. Today, almost everyone has a camera – of a technical sophistication that would astonish earlier generations – which only requires you to 'point and shoot' to capture a perfect image of reality. Or, so it seems.

This book is about what it means to make a representation of the world and how photographing the world affects our understanding of it and of ourselves.

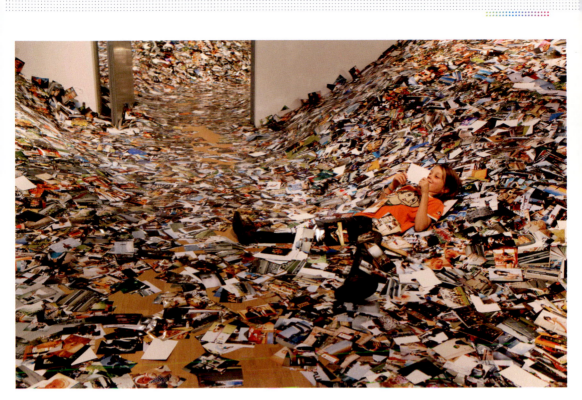

0.1

'[Photography is] so easy it's ridiculous…
After all, it's just looking at things. We all
do that. It's simply a way of recording
what you see – point the camera at it, and
press a button. How hard is that? …
It's so difficult because it's everywhere,
every place, all the time, even right now.
But if it's everywhere and all the time, and
so easy to make, then what's of value?
Which pictures matter?'

Paul Graham, fine-art photographer

0.1

Title: 24 hours in photos, 2011

Artist: Erik Kessels

For this installation at Foam,
Amsterdam, Holland, Kessels
printed out the one million
photographs uploaded to the
Internet in a single 24-hour period.

What is the use of theory?

It is perfectly possible to live a rich and creative life without ever tangling with the vocabulary and technicalities of, for example, semiotics, which can seem at best difficult and at worst simply irrelevant.

The point here is not to propose theory as an end in itself, but to argue that theory is intrinsic both to the practice of photography and the everyday engagement with photographs. In fact, whether they know it or not, most people are already expert semiologists. For example, when we meet a new person we will very quickly make an assessment of them based on what they look like, what they wear, what they sound like and how they behave – that is, we 'read' them as a set of signs, as a 'text'. This is semiotics. In exactly the same way we very quickly 'read' photographs, and everything else, come to that. The value of theory is that it offers a toolbox for unpicking this process in more detail and can enhance understanding of how and why a photograph works, and what it means.

Nevertheless, it can seem that theory can 'get in the way' of intuitive and instinctive practice. You look, you point, you shoot. You don't need to think about that process – at least, not consciously. Seeing the picture is exciting, whether it is the deferred pleasure of film processing or the instant gratification of the digital image, which you can look at right away, review, delete or save, reshoot, and make better. You, the photographer, are the first viewer of the picture; the first reviewer; the first reader. Sometimes you see exactly what you expect to see, sometimes you can be surprised. Evaluations are made about the framing, the focus, the depth of field, the lighting, the colour – is it right? What does it say? What does it mean?

This book is about how a photograph means what it means and will begin by considering what, exactly, is a photograph.

'"The illiteracy of the future", someone has said, "will be ignorance not of reading or writing, but of photography." But must not a photographer who cannot read his own pictures be no less accounted an illiterate? Will not the caption become the most important part of the photograph?'

Walter Benjamin, writer and critic, from *A Small History of Photography*, 1931

What is a photograph?

Chapter 1 will look at the invention of photography and consider how the principles of photography affect the way we think about the meaning of a photograph.

Reading the signs

Chapter 2 will introduce the theory of semiotics and show how making sense of photographs can be understood as a process of reading.

Truth and lies

Chapter 3 focuses on the relationship of a photograph to what it represents and will consider the claim that 'the camera never lies'.

Identity

Chapter 4 explores the role of photographs in relation to individual identity and their effect on how we see ourselves and others.

Big Brother is watching you

Chapter 5 examines how photography has been used as an instrument of surveillance and voyeurism.

Aesthetics

Chapter 6 will discuss the uneasy relationship of photography to art and what it means to claim a photograph as art.

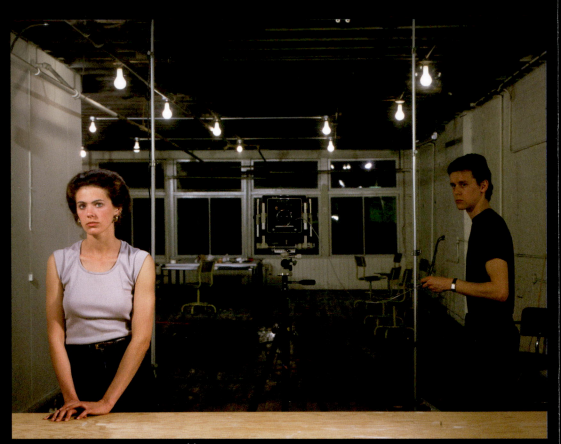

1.1

1

1.1

Title: Picture for Women, 1979

Photographer: Jeff Wall

Wall's photograph includes both the camera and the photographer and, thus, reveals the normally invisible relationship of camera to subject. Or, it seems to; disconcertingly, there is ambiguity about whether we are looking into the illusory space of a mirror reflection or into a representation of 'real' space.

The structure of the picture refers to Édouard Manet's 1882 painting, *A Bar at the Folies-Bergère*, in which the viewer is apparently cast in the role of a gentleman (revealed in a mirror reflection that doesn't quite 'work') engaging with a barmaid who looks directly at us. The complex geometry of gazes and reflection in Wall's picture teasingly demonstrates photography's seductive blurring of illusion and reality.

What is a photograph?

A photograph is a ghost of a moment that has passed – the trace of the light which makes the world visible. The word 'photograph' literally means 'drawing with light'. A camera stops time and allows us to witness moments from history – or so it seems. The precise status of the photographic image and its relation to the scene that is recorded is one that is difficult to settle.

However, the essential principles of photography can be clearly stated. In order to make sense of photographs, it is important to understand the nature of the medium and its evolution: how we read a photograph is significantly determined both by the specific characteristics of the process and by our grasp of that process.

This chapter sets out the founding principles of photography and chronicles the pioneering experiments that brought about its invention. The phenomenon of the camera obscura is examined and consideration is given to the assumptions about truthfulness that have flowed from its operation.

Camera obscura

Although photography is less than 200 years old, it is the product of natural phenomena that have been known about for centuries: the optical phenomenon of the camera obscura, and the chemical effect of light on certain materials causing them to darken, lighten, soften or harden.

The principle of the camera obscura (literally 'dark room') is that if a wall of a windowless room, or a side of a sealed box, is pierced with an aperture, then an image of the scene outside the room or box will appear, upside down, on the opposite wall of the chamber. Knowledge of this principle is thought to date back to ancient China, when, according to historian Naomi Rosenblum, in the fifth century BC, Mo Ti observed the phenomenon. It was certainly in use during the Renaissance and many artists have employed variations of the device as a drawing aid – by tracing the projected image, the artist could quickly and accurately produce a two-dimensional representation of the scene. The painter David Hockney has written of the 'secret knowledge' by which artists such as Jan van Eyck, in the fifteenth century, used a camera obscura and a mirror to achieve the remarkable detail in, for example, *The Arnolfini Portrait* (1434).

It is the apparent faithfulness of the camera obscura that gives rise to the belief that a 'camera never lies'; the image, after all, is determined by the laws of optics. The world and its objects are visible to us because they reflect and absorb light, and it is this same pattern of light that is recorded and preserved in a photograph. However, while this is undeniably how a photograph comes about, the 'truth' of the matter is more complex and will be explored later in this book.

Photograms

Images, produced by light, can be made without the aid of a camera. Photograms are made by placing objects directly onto light-sensitive material before exposing it to light. The object masks an area identical to itself, creating an image of unexposed, un-darkened material. However, when the object is removed to reveal the image, the image itself is exposed and will darken and disappear – unless the process can be halted. It was the ability to halt the light sensitivity of the material and 'fix' the image that made photography possible. When this chemistry was married to the optics of the camera obscura, photography was born.

1.2

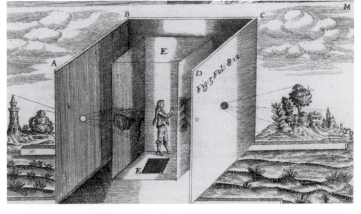

1.2

Title: Large portable camera obscura, 1646

Source: Athanasius Kircher's *Magna Lucis Et Umbra* (The Great Art of Light and Shadow), 1646

This seventeenth-century engraving illustrates the principles of the camera obscura, as exploited by artists long before the 'invention' of photography.

1.3

Title: The Arnolfini Portrait, 1434, National Gallery

Artist: Jan van Eyck

The astonishing detail and realism of this fifteenth-century painting is, in part, accounted for by van Eyck's skilful use of the innovations associated with oil paints and glazes. However, it has also been suggested that he may have used a camera obscura as an aid towards drawing the fine details: projecting a two-dimensional image which could then be traced. While in van Eyck's case this remains a matter of speculation, its use by later artists is well documented.

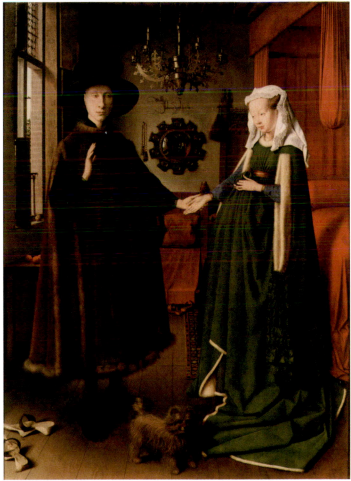

1.3

Cameraless photography

In 1802, the British chemist and inventor Humphry Davy reported on experiments he and Thomas Wedgwood had carried out with light-sensitive silver compounds. They had succeeded in creating 'shadow pictures' made from objects placed upon paper or leather, which had been immersed in silver nitrate. However, they had been unable to stop the process and preserve the image.

Around 1834, William Henry Fox Talbot, (1800–1877) one of the most notable contributors to the invention of photography, discovered that a solution of salt halted the light sensitivity of silver compounds. He termed his results 'photogenic drawings'. He placed a leaf onto sensitized paper, which he then left out in the sun. The paper darkened around the edge of the leaf to form a silhouette, and where light passed through the leaf's translucent veins it registered their pattern, too. By soaking the paper in a solution of salt, the image was fixed.

Shadow catchers

Fox Talbot quickly moved on to experiment with camera-based images, but the photogram has had many notable exponents since. Using the cyanotype process, which uses iron salts to produce a deep blue image, Anna Atkins produced beautiful and scientifically valuable photograms of botanical specimens. In the 1920s, avant-gardists, such as László Moholy-Nagy and Man Ray, explored the abstract and surreal qualities of the process – the latter calling his experiments 'Rayographs'.

While the photogram – essentially a contact print – is arguably the most primitive form of photography, it is nevertheless capable of producing images of great beauty and mystery, and is very much alive today. In 2010, the Victoria and Albert Museum in London held an exhibition called *Shadow Catchers: Camera-less Photography*, which featured five contemporary image makers including Floris Neusüss, whose work includes *Körperfotogramms* ('whole-body' photograms). Neusüss visited Lacock Abbey in Wiltshire, England, and made a photogram of the window which Fox Talbot had famously photographed in 1835. Fox Talbot's picture measured 1½ inches square – Neusüss' picture is life size!

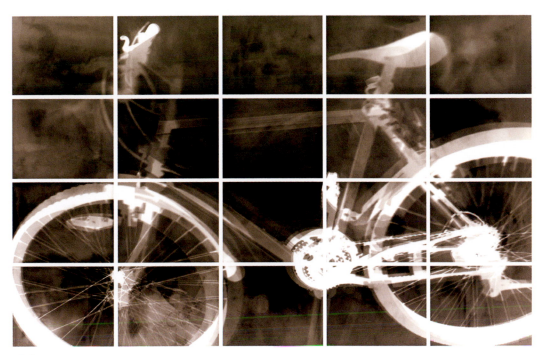

1.4

1.4

Title: Bicycle, 2012

Photographer: Lisa Lavery

To make this photogram, Lavery laid 20 sheets of photographic paper on the floor of a room illuminated by a safelight, laid the bicycle on the paper and, using a handheld flash, exposed the paper to three flashes. The separate sheets were developed and reassembled to construct a life-size image of the bicycle.

Daguerreotypes

Commonly regarded as the 'first' photograph, Nicéphore Niépce's (1765–1833) *View from the Window at Le Gras* taken in 1826, is a shadowy image of rooftops. Niépce inserted a pewter plate coated with bitumen into a camera obscura, exposed it to sunlight for eight hours, then washed it with oils which dissolved the bitumen that hadn't been hardened by light. The resulting unique image – called a 'heliograph', ('sun drawing') – was inscribed by his associate Francis Bauer, as *Monsieur Niépce's first successful experiment of fixing permanently the image from nature.*

In 1829, Niépce formed a partnership with Louis-Jacques-Mandé Daguerre (1787–1851); together, they discovered that polished silver-plated copper treated with iodine fumes would darken when exposed to light. However, it was after Niépce's death, in 1833, that Daguerre made the crucial discovery that treating an exposed silver iodide plate with mercury vapour would develop the latent image on the plate. This meant that the time required for exposure could be reduced from a matter of hours to minutes: in 1839 this was about 30 minutes, by 1842, with the use of other silver compounds as well as the use of lenses in the camera, it was down to a minute or less.

The daguerreotype was a sensation. The process was able to produce images of detail and clarity that was astonishing and provoked the legendary observation, attributed to painter Paul Delaroche, *From today, painting is dead!* While it is easy to understand the delight of nineteenth-century viewers and the immediate popularity of daguerreotypes, especially for portraits, it is less easy to appreciate exactly what they saw.

Ironically, given that the process was dubbed 'the mirror with a memory' and taken to be a faithful record of the truth, every reproduction of a daguerreotype, including those in this book, is misleading and effectively misrepresents them. Daguerreotypes are delicate and are normally displayed behind glass – in a frame or in a velvet-lined case. Viewed from one angle they seem to be just mirrors, but turned to another, the image becomes visible.

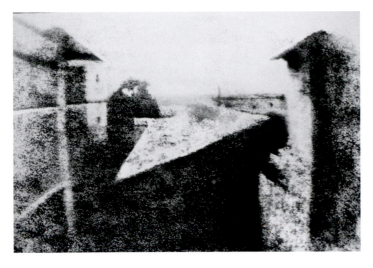

1.5

Title: View from the window at Le Gras, c. 1825–1826

Photographer:
Joseph Nicéphore Niépce

The 'first' photograph exists as a unique, shadowy image on a pewter plate, and is held in the collection of the University of Texas. This reproduction is 'enhanced' by modern technology to give greater clarity. Because the exposure took more than eight hours, the sun has travelled across the sky so that both sides of the building are illuminated.

1.6

Title: Boulevard du Temple, Paris, c. 1838

Photographer: Louis-Jacques-Mandé Daguerre

While the architectural detail visible in this very early daguerreotype is remarkable, the Paris boulevard is strangely deserted – almost. Only a man having his boots cleaned remained still long enough to be recorded in the lengthy exposure (ten minutes, or more) required to make the picture.

1.6

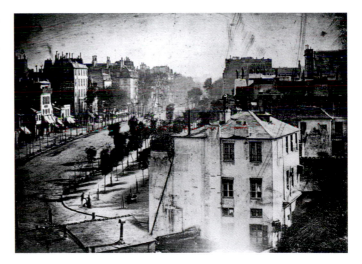

Negatives and positives

Every daguerreotype is a unique object: the image is identical to the plate that was exposed in the camera and cannot be reproduced – except by other photographic processes. Thus the daguerreotype, for all its beauty and detail, lacked the one thing that has become the defining characteristic of all subsequent photographic processes: reproducibility.

That possibility came about with Fox Talbot's negative-positive process – although its potential, which we now take for granted, may not have been immediately apparent. Talbot's calotype process used paper coated with silver nitrate and potassium iodide: when exposed and fixed, the image produced was a negative of the scene photographed. It was then possible to exploit the translucency of paper (later sometimes enhanced by waxing – notably by Gustave Le Gray) to make a positive print by laying it over another sheet of paper coated in silver nitrate and salt, and exposing to sunlight – contact printing. Any number of positive prints could be made in this way and it permitted Talbot to produce the first photographically illustrated book, *The Pencil of Nature* (1844–1846).

Generally, these paper-based images were not as finely detailed as daguerreotypes and were consequently slower to achieve popularity; nevertheless, in the hands of artists such as David Octavius Hill (1802–1870) and Robert Adamson (1821–1848) remarkable results were achieved.

Wet collodion process

A process that combined the clarity and detail of the daguerreotype with the reproducibility of the calotype was developed by Scott Archer in 1850. The wet collodion process permitted the spreading of a colourless, grainless light-sensitive material onto glass.

The preparation for and execution of this process was both delicate and complex and had to be calculated to ensure that the quick-drying collodion remained wet at the moment of exposure. The resulting glass negative could be used to contact print sharp and clear images. Despite the awkwardness of this process, it remained popular until the 1880s when flexible celluloid film was introduced.

1.7

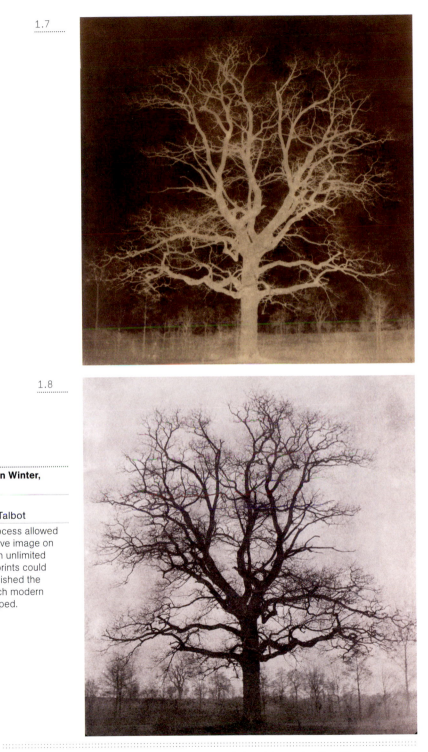

1.8

1.7–1.8

Title: An Oak Tree in Winter, c. 1842–1843

Photographer:
William Henry Fox Talbot

Talbot's calotype process allowed the fixing of a negative image on paper, from which an unlimited number of positive prints could be made: this established the principles upon which modern photography developed.

A photograph is made of time and light

Our understanding of life is framed by time, from birth to death, and from morning to night. While our experience is only ever of the continuous present, our understanding is shaped by history and memory. A photograph is always of time past, a moment fixed for all time: it is history.

The visible world, its colours and forms, is perceptible to us because of light, and it changes with the light. The colours of a winter morning are very different to those at high noon in the summer.

We place a lot of faith in the truth of what we see: 'seeing is believing'; yet, because we experience the world in flux, and because we tend to interpret what we see through the 'lens' of our experience and beliefs – looking perhaps through rose-tinted glasses – we bring a high degree of subjectivity to the process of perception. It is tempting to think that the mechanical eye of the camera brings a reliable objectivity to the process – yet the operations of a camera are precisely a matter of regulating the transmission of light – the design of the lens, the choice of aperture and exposure time, the light and colour sensitivity of the film or sensors all combine to produce the picture; change any of the parameters and you change the character of the picture.

Nevertheless, what does appear in a photograph is determined by what is in front of the camera. The optics and mechanics of the camera's systems can see and show what the unaided human eye can never see.

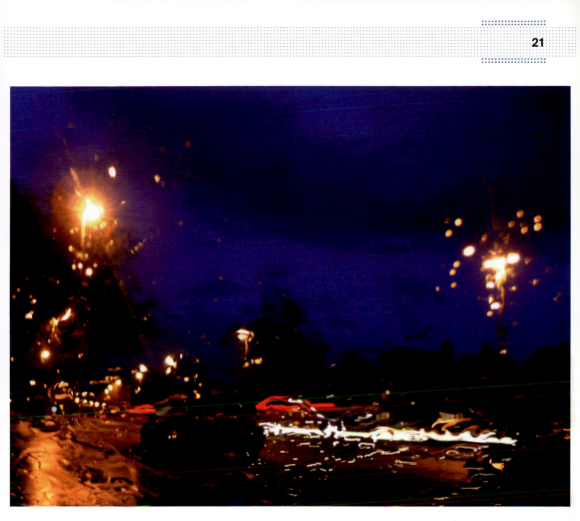

1.9

1.9

Title: Estcourt Road, 2009

Photographer: Richard Salkeld

Photographed on a dark and rainy night, the necessary long exposure results in an image that is perfectly readable, but shows a scene that the eye would not see. The light trails are an index of time and movement; refracted through the water on the glass screen, they become smears of colour, which give a painterly quality to the image – as well as signifying rain.

Stillness and movement

Daguerre's 1838 picture of the Boulevard du Temple (page 17) shows us an almost deserted street: pedestrians and traffic simply moved too quickly to be registered during the necessarily long exposure; only the anonymous person having his shoes shined remained still enough to be in the picture. As exposure times shortened, more of the world could be recorded.

Nevertheless, at first, only stationary objects could be recorded with absolute clarity; movement could, of course, be signified by blur. The human eye registers movement very efficiently, but try as we may we cannot see the galloping horse's legs or the bird's wings – we cannot, in truth, tell the dancer from the dance. The analysis of such movements is clearly of considerable scientific and artistic interest; one of the great gifts of photography has been the stop-motion picture – the freezing of not just a moment in time, but of the structure of movement itself. Edgar Degas' many paintings of ballet dancers are testament to an exceptional quality of looking and drawing, of hand-to-eye coordination married to a knowledge and understanding born of close observation. But, however keen the artist's eye, he cannot freeze the movement except to ask the model to pose – and thus destroy the dynamic flow of movement.

Muybridge and Marey

It is one thing to ask a dancer to pose, another to get a galloping horse to do so. Artists' attempts to represent such movement look absurd and unconvincing to the modern eye: it is photography that has supplied the information to render it so.

Eadweard Muybridge – who had made his name in the 1860s as a photographer of San Francisco and Yosemite – was employed by Leland Stanford, a businessman and racehorse owner, to resolve the debate about how a horse's legs actually moved; information that would also be invaluable for training. Around 1877, Muybridge achieved this aim by setting up a series of 12 cameras (later experiments doubled this number) to photograph, in sequence, a horse moving in front of a calibrated backdrop, thus producing a precise sequence of positions. The results of this and later work were published as *Animals in Motion* and *The Human Figure in Motion* and remain in print today.

Muybridge's discoveries were seen as sensational and inspired other photographers to experiment.

The French scientist Étienne-Jules Marey called his studies of movement 'chronophotographs'. He used a 'gun camera' (which had a revolving photographic plate rather than a bullet chamber) to capture the movement of birds in flight.

Such work was, for the most part, produced purely for scientific research. However, the results have undoubted aesthetic appeal and have been of lasting inspiration to artists. The most substantial legacy of these experiments is the development of cinema: once movement had been broken down into sequential images, it was a logical step to reconstitute the movement by viewing the images in rapid succession. Muybridge, Marey and others, experimented with a range of optical devices before cinematography. This method of moving celluloid film through both a camera and a projector was developed and refined by the Lumière brothers in France around 1895.

1.10

Title: Galloping horse, 1878

Photographer: Eadweard Muybridge

Muybridge's cameras revealed the truth of a horse's movement – including the moment when all four hooves leave the ground – which no eye had been able to discern. The knowledge gained from such revelations, afforded by photographs, has profoundly influenced how we subsequently perceive the world.

1.10

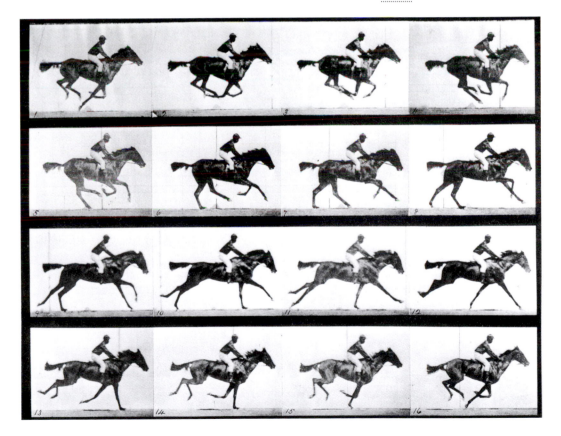

The optical unconscious

The writer and critic Walter Benjamin may well have had Muybridge's and Marey's images in mind when he proposed the idea of an 'optical unconscious' in his 1931 essay 'A Short History of Photography'.

The term is, perhaps, a little imprecise in its implication, but what is very clear is that a great deal of our understanding of the world depends upon visual information that we cannot actually see or have not witnessed. The visual data which a photograph may have revealed about the movements of, for example, a bird's wings, has now constituted knowledge that we unconsciously apply in our everyday observations.

With the development of strobe photography and X-rays, we can even see, and know, a speeding bullet and the skull beneath the skin.

Arguably, we know the world better through its photographic representation than through direct experience. Our visual memories are stocked well in excess of what we have directly experienced; a phenomenon which has only accelerated with the growth of digital-media culture.

We like to think that photographs from our past simply trigger memories; but can we be sure that it is not the photographs that produce the 'memories'?

Walter Benjamin (1892–1940)

German critic and academic, Benjamin was a pioneer in the study and theorization of photography. His 1936 essay, 'The Work of Art in the Age of Mechanical Reproduction' is a key text in the study of the medium. Benjamin argued that the invention of photography was revolutionary and democratizing in its effect upon how we experience and understand the world, and that it transformed the idea of art. In 'A Short History of Photography' (1931) he proposed the idea of an 'optical unconscious', meaning that photography had enhanced our perceptions of the world beyond what we could otherwise see. These essays are collected in *One-Way Street and Other Writings* (2009).

'It is possible… to describe the way somebody walks, but it is impossible to say anything about that fraction of a second when a person starts to walk. Photography, with its various aids (lenses, enlargement) can reveal this moment. Photography makes aware for the first time the optical unconscious, just as psychoanalysis discloses the instinctual unconscious'.

Walter Benjamin, writer and critic

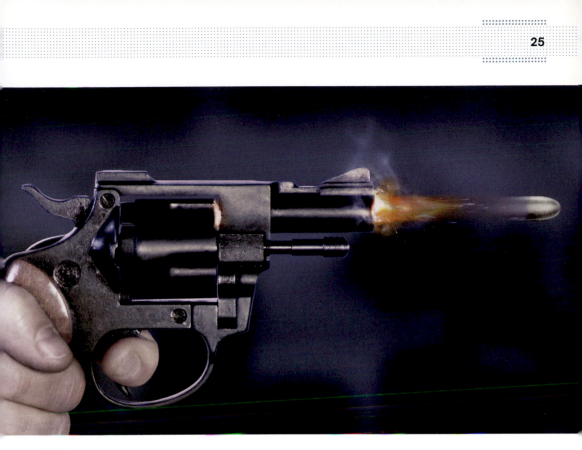

1.11

1.11

Title: Close-up of a bullet coming out of a gun

Photographer: Cocoon

Harold Edgerton pioneered the use of strobe lighting to produce stop-motion images in the 1930s. Short bursts of intense light allow the camera to record, as here, an event which no eye could see. Arguably, the knowledge gained from such images is absorbed into our perceptions: we 'see' what we 'know'.

Early conceptions of photography emphasized that pictures were produced by a natural process – 'sun drawings', *The Pencil of Nature* – that, in effect, photographs 'made themselves' without interference from human imagination or manipulation and were truthful and realistic representations of the world and its objects. Such a conception tends to suggest the medium as a tool of science and evidence, rather than art, and clearly anticipated its role as documentary.

Although announced to the world in 1839, photography did not really begin to achieve mass public reach until the 1880s when the development of halftone printing made it possible to reproduce photographs directly, rather than employing an engraver to copy them. Thus, photojournalism, the reporting and documenting of newsworthy events, began. However, it was not until the 1920s and through the 1930s that improvements in printing, the development of lightweight handheld cameras and wire telegraphy, transformed photography into the principal news medium of the period.

The proliferation and popularity of photographically illustrated magazines were part of a wave of new communications media, which transformed culture and are indelible markers of modernity; as such, they are also part of the bigger story of industrialization, mass culture, capitalism, consumerism and… advertising. Advertising was not invented with photography, but its scope and ambition were hugely enlarged – as they would further be by the later arrivals of television and the Internet.

Arguably, photography is definitively a commercial medium: its technological nature lends itself to industrialization and mass production. Photography's combination of apparent objectivity with seductive imagery, exemplified by advertising and fashion photography, is a winning combination.

1.12

Title: Woman in a yellow swimsuit, c. 1960

Photographer: Zoltán Glass

The career of Hungarian-born Glass developed alongside the rise of the picture magazine and the evolution of a photographic industry encompassing photojournalism, advertising, fashion and pin-ups. Glass worked in Berlin in the 1930s before fleeing to London to escape Nazism. In London, he established himself as a highly successful commercial photographer. The use of colour and the exuberance of this swimsuit shot captures the emerging spirit of 1960s optimism.

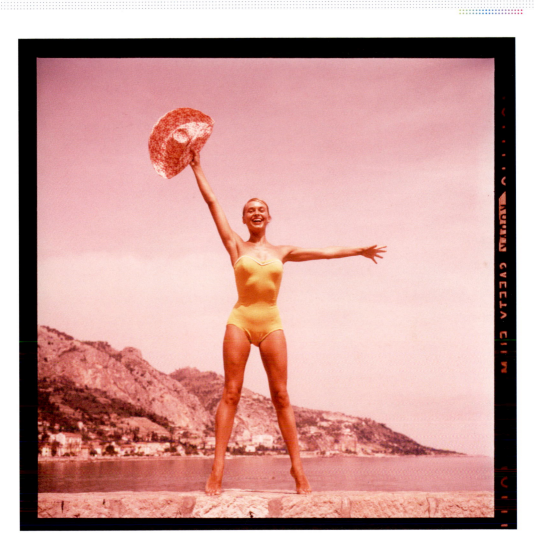

1.12

The democratic image

Handmade pictures are unique objects – available for viewing in one place at a time; furthermore, many of the historical works of Western art have been the private property of a privileged class of princes and aristocrats. One of the democratizing measures of the French Revolution (1789) was the seizing of the Louvre Palace and the royal collection of art to create a public art museum; other major European and American cities followed suit with public art museums established in the nineteenth and early twentieth centuries.

Although the contents of such museums may have 'belonged' to the public, a pilgrimage was still required to see them. In 1936, Walter Benjamin argued that photographic reproduction meant that otherwise unique works of art could be 'liberated' from their singular location and effectively made available to anyone, anywhere. Initially, this was by means of cards and books; today, it can include a 'virtual tour' of the gallery from a computer desktop.

Two important ideas follow from the intervention of photography into the traditions of art consumption. First, the effect of making reproductions of unique works of art widely available is to radically re-contextualize the work, to put it into new situations and relationships: it is to change the way we see it, or 'read' it. Furthermore, as Benjamin points out *photography… can bring out those aspects of the original that are unattainable to the naked eye yet accessible to the lens.*

Secondly, there is the matter of the photograph as a work in its own right; the logic of photography's reproducibility means that the notion of uniqueness is shattered – in principle, anyone who wanted it could have a copy of a photograph. Furthermore, the means to make images is available to all – perhaps the camera makes everyone an artist?

The status of photography as fine art is discussed in Chapter 6.

'When the camera reproduces a painting it destroys the uniqueness of its image. As a result, its meaning changes. Or more exactly, its meaning multiplies and fragments into many meanings.'

John Berger, writer and critic

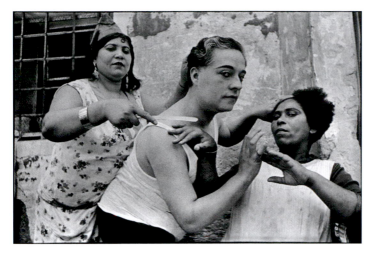

1.13

1.13

Title: Alicante, 1933

Photographer:
Henri Cartier-Bresson

In the democracy of photography everyone can be represented. Cartier-Bresson typically found his extraordinary subjects on the ordinary street. This enigmatic scene exemplifies his ability to catch the decisive moment when the flow of everyday life is suspended in a dynamic image of rhythm and form.

1.14

1.14

Title: The Sistine Chapel ceiling, c. 1508–1512

Artist: Michelangelo

This detail of Michelangelo's Sistine Chapel ceiling will be familiar to many – including those who have never been to Rome. However, even those who have stood in the chapel and looked upwards will not have seen it in such clarity and detail. Photography has transformed our knowledge of works of art and, arguably, their very meaning.

Art for everyone

When, in 1839, the French politician François Arago introduced the Daguerreotype process to his peers, he declared that it *calls for no manipulation which anyone cannot perform… there is no one who cannot succeed as certainly and as well as can M. Daguerre himself.*

In fact, the complications of photography until the 1870s and the introduction of the gelatin dry plate meant that it initially remained the province of professionals and enthusiastic amateurs. Nevertheless, the popular appeal was such that, according to historian Helmut Gernsheim, the first photographic portrait studio opened in New York in 1840, and by the following year there were such studios in most of the principal towns in the USA. In London, Richard Beard established a studio in 1841 which, Gernsheim notes, 'attracted business beyond his wildest dreams'. By 1853, the price of a portrait was as little as two dollars – it was affordable for most, if not all, classes.

Around 1854, French photographer, André Disdéri perfected the *carte-de-visite*, so called because the pocket-sized images, each about 3½ x 2½ inches, were the size of a calling card. By constructing cameras with multiple lenses so that many small, different portraits could be made on a single plate, the cost of each was dramatically reduced. The mass production of portraits of the famous, such as Napoleon III and Queen Victoria, created a collecting craze; according to historian Naomi Rosenblum, sales of pictures of Prince Albert reached 70,000 and Abraham Lincoln ascribed his election as US President in 1861, in part, to Mathew Brady's 1860 *carte-de-visite* portrait of him.

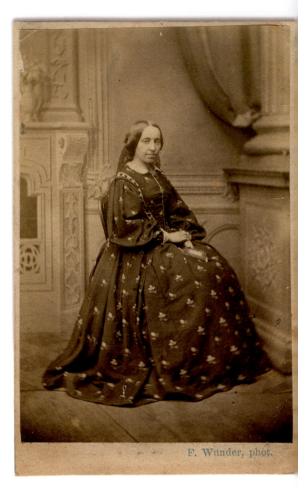

F. Wunder, phot.

1.15

1.15

Title: Pauline, carte-de-visite, c. 1865

Photographer:
Karl Friedrich Wunder

Wunder was a successful German photographer who included Karl Marx among his customers for *cartes-de-visites*; his subject here is known only as Pauline.

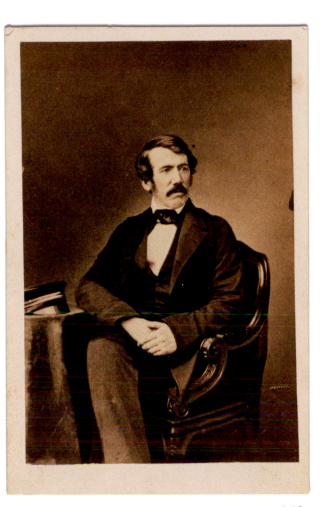

1.16

1.16

**Title: David Livingstone, carte-
de-visite, c. 1857**

Photographer:
John Jabez Edwin Mayall

Mayall set up a daguerreotype
business in London in the 1840s
and became famous after
photographing Queen Victoria and
Prince Albert. His subject here is
another celebrity, the great explorer
of Africa, David Livingstone.

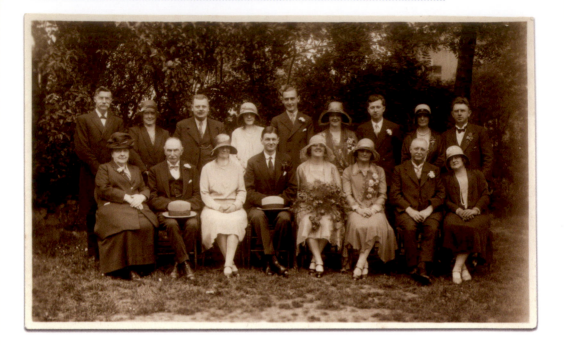

1.17

You press the button...

The marketing of the Kodak camera by George Eastman in 1888 finally put the means of photograph production into the hands of the masses. The company's famous slogan: *You press the button, we do the rest*, summed up the simplicity of the process. The simple handheld box camera was sold preloaded with sufficient film for 100 exposures; when all had been used, the whole camera was returned to the company who developed the pictures and reloaded the camera. Anyone could now be a photographer – though not necessarily a good one!

The Kodak No. 1 and its subsequent refinements were very cleverly and effectively marketed to create a culture of amateur and domestic photography. A series of advertising slogans advocated the pleasures of holiday snapshots (*A vacation without a Kodak is a vacation wasted*) and of family life.

Thus, the conventions of recording those special family occasions – holidays, birthdays, first days at school, graduations, weddings, babies – were firmly established. Indeed, as Sarah Kennel has shown, the importance of documenting these rites of passage was presented almost as a moral duty: a 1936 Kodak advertisement shows a proud father showing photos of his children to another man who reflects: *I felt ashamed... why hadn't I taken snapshots of mine?*

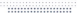
1.17

**Title: Swindon wedding party,
c. 1920s/30s**

Photographer: Fred C. Palmer

A wedding photograph may only be
of particular interest to members
of the family – but a great gift of
photography is that relations can
reach across the generations to
see their forbears, whom they
may never have met and yet may
recognize through family likeness.

Happy families

Overwhelmingly, of course, family
snaps show happy occasions (funerals
remain, largely, an exception to the
list of photographable family events)
for which the subjects willingly turn to
the camera, smile (say cheese!) and
perhaps strike amusing poses. The irony
is that the 'special moments' that are
actually recorded existed only for the
purpose of making the photograph.

In most cases this little 'fiction' is well
understood and is a part of the ritual of
domestic snaps – though the duty to
'smile' for the camera may briefly disguise
tensions and emotions not deemed suitable
to record. However, it has been argued by
Judith Williamson that such photography
has played *a central role in the development
of the contemporary ideology of the family…
it could make all families look more or
less alike*. In this way, family photography
works to construct and reinforce the
conventional ideal of the 'happy family'.

Arguably, contemporary social trends
have moved away from the nuclear family
towards more fluid patterns of living, and
together with the explosion in digital
photography linked to social networking,
this has given rise to much more diverse
and spontaneous representations of social
life, capturing not just the special occasions,
but everyday casual moments. Furthermore,
these images have escaped from the
confines of the private family album to
be instantly published on the Internet.

Seeing the world

The very existence of photography has changed the world – insofar as the images produced have transformed our knowledge, understanding and experience of the world. From the first, adventurers took their cameras across the world to document exotic and exciting locations, for example, Francis Frith (1822–98) in Egypt, Samuel Bourne (1834–1912) in India and John Thomson (1837–1921) in China. The fruits of these enterprises fed not just a hunger for knowledge, but nourished an incipient global tourist industry – an industry which is practically defined by photography, from the website brochure, through to postcards and the essential holiday snaps.

However, the idea of the 'exotic' is not simply a romantic one, it also carries connotations of foreignness or otherness which, in the context of nineteenth-century Western colonialism, shade into ideologically charged representations of power and exploitation. The Western perception of 'native' traditions as quaint, or even primitive, can render cultures into spectacles for the tourist, in which locals pose as stereotypes of themselves to satisfy tourists' desires to capture 'authentic' pictures.

1.18

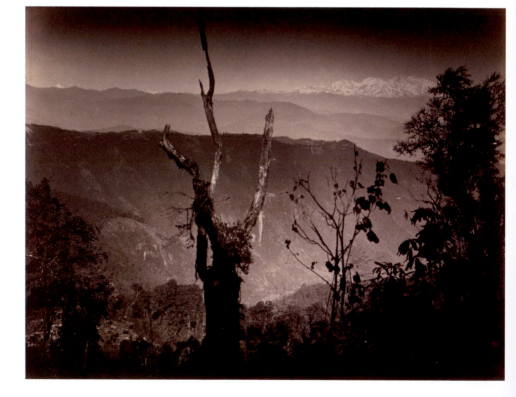

1.19

1.18

Title: View from Senehal, c. 1867

Photographer: Samuel Bourne

Following a successful exhibition of
his photographs in London, in 1862,
Bourne travelled to India where he
established a successful business
in Calcutta. Between 1863 and
1871, he undertook three ambitious
photographic expeditions into the
Himalayas. Bourne's remarkable
pictures of this remote landscape
are made even more impressive
knowing that he was using the
complicated and demanding wet
collodion process (see 18) requiring
the transport of hundreds of glass
plates, crates of chemicals, tents
and cameras – the assistance of
some forty porters was invaluable!

1.19

Title: *from Small World*, 1995

Photographer: Martin Parr

Parr's book *Small World*, takes
global tourism as its subject.
Parr is fascinated by the gaps
between the photographed
promises of holiday brochures
and the reality experienced, as
well as the seemingly universal
compulsion, born of photography,
for us all to take the same pictures
of the same exotic sites and,
crucially, to be photographed
in front of those sites. Here, he
photographs the photographer
and the photographed.

Changing the world

Photography clearly feeds an appetite for armchair travel – we hungrily consume the beautiful and fascinating pictures of places we are never likely to see first-hand. However, photographs can also show us people and places we would perhaps rather not visit – even though they may be close at hand. Photographers such as John Thomson in London, Thomas Annan in Glasgow and Jacob Riis and Lewis Hine in New York took their cameras into the streets, slums and factories to expose living and working conditions that shamed modern city life.

The honourable tradition of the 'concerned photographer' derives from such enterprises and the camera has proved to be a powerful weapon in the cause of social change, not least as a witness to events and actions, so that popular opinion can be mobilized to affect economic or political responses to military struggles or natural disasters. The often dangerous work of professional photojournalists is today supplemented by the ability of those directly involved in struggles to use camera phones to instantly transmit pictures of events as they happen.

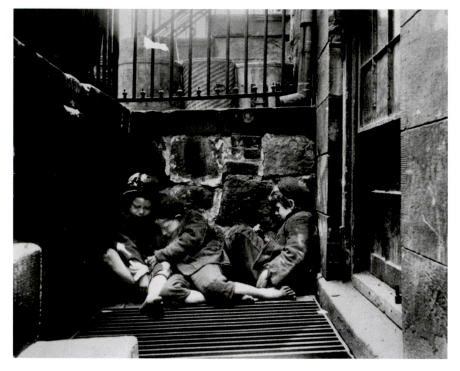

1.20

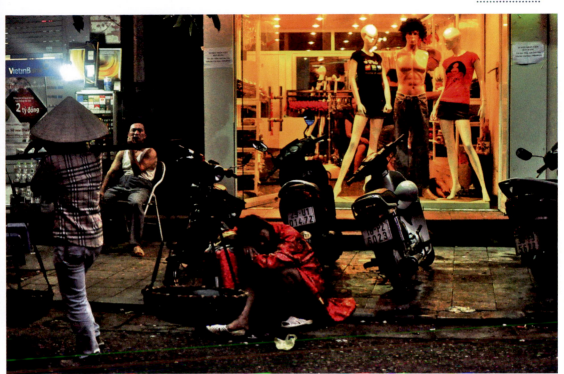

1.21

1.20

Title: Children sleeping in Mulberry Street, 1890

Photographer: Jacob Riis

In his use of photography to illustrate his accounts of slum conditions in New York, in the 1880s and 1890s, Riis can be regarded as one of the fathers of concerned photojournalism. However, he was not above using a little dramatic licence – it may be that the children here are pretending to be asleep.

1.21

Title: Hanoi Junkie, 2012

Photographer: Joanna Casey

People on the street seem indifferent to the plight of this woman; though, apparently, wearing a glamorous dressing gown, the reality of her situation makes a stark contrast to the brightly lit world of the clothes shop behind.

Photography is a technology and, as such, the specific characteristics of a photograph – and how it will be 'read' – will be determined by the nature of the equipment and processes employed: a print from a photograph made in a large-format camera will look very different to one made on a camera phone; black and white is very different to colour.

The choice of camera affects how people react. A large camera may appear intimidating and invite a serious, formal response, whereas a small, handheld camera may provoke a more spontaneous and expressive reaction. On the other hand, a small camera 'in your face' may seem aggressive or intrusive.

Photography has evolved from Frederick Scott Archer's invention of the wet collodion process in 1851 – which triumphantly combined the clarity of the daguerreotype plate with the reproducibility of Fox Talbot's negative-positive process, but involved the tricky manipulation of wet chemicals on sheets of glass – through the relative convenience of Richard Leach Maddox's invention of the dry gelatin plate in 1871, to the use of celluloid film in 1889. This remained the dominant photographic medium for a century until the emergence of digital technology in the 1990s.

1.22

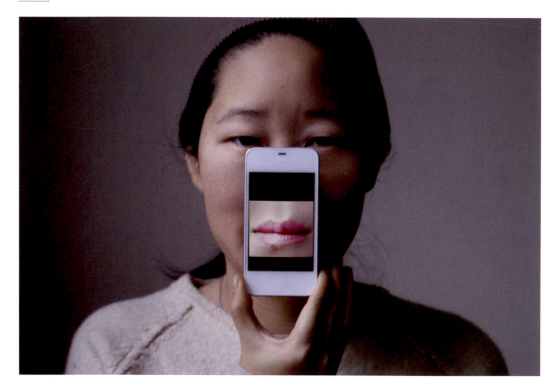

Digital photography

Digital technology has transformed photography. In place of light-sensitive film, digital cameras record images onto electronic light sensors. The image is stored as a digital file that can be viewed instantly on a screen in the camera, and directly transferred to a computer for editing and printing.

Digital technology has not only been employed in formats equivalent to large, medium and small format film, but is now routinely incorporated into mobile phones and other handheld electronic devices. This latter innovation has transformed personal photography by not only putting a camera into the pocket of anyone with a mobile phone, but also allowing instant dissemination through social networks. Whereas the family camera was typically only brought out for special occasions – birthdays, holidays, weddings – now, any moment may be recorded.

The convenience, speed, sophistication and flexibility of digital technology mean that it is now the industry standard for image production and the medium of choice for the popular market.

Photographers may still choose to use film, preferring the more organic character of the process and the slower, more considered approach to composition that it encourages. However, even where film photography is still employed to make the image, the 'output', that is the published, exhibited or networked picture, is now predominantly digital.

1.22

Title: Portrait of a woman with her mobile phone, 2013

Photographer: Maciej Toporowicz

Digital technology has refreshed photography as a popular, social and playful medium, as well as reinvigorating and expanding professional media communications.

Case study
Chuck Close

The story of photography is one of technological evolution from daguerreotype to digital. Generally, the decisive factors in the triumph of one system over another have been a combination of pictorial clarity, convenience of use and reproduction and, crucially, commercial and industrial investment.

Each system is defined by both a distinctive, visual character, and a particular working method and craft practice. Although successive processes (cyanotype, wet collodion, dry gelatin plate, Polaroid, celluloid film) have all become commercially redundant, all remain in use today not just as quaint historical curiosities, but as genuinely creative methods of image-making.

As outlined in this chapter, the daguerreotype has come to be seen historically as both a truly revolutionary invention which astonished the world and became, in the 1840s and 50s, a huge commercial success. However, it proved to be a false start in the story of photography, fatally limited by its lack of reproducibility.

And yet it survives. In fact, according to critic Lyle Rexer, the clarity of the daguerreotype remains unsurpassed – but to appreciate this you have to see the object itself!

Chuck Close is an artist best known for his astonishing, large-scale photorealist paintings of heads; his career has been an ongoing dialogue between painting and photography. In fact, by David Campany's account, Close virtually is a camera: he typically works from inverted photographs, laboriously transcribing their visual data onto a gridded canvas: 'in some respects this corresponds to the mechanical indifference of the optical camera lens, which inverts the image it casts.'

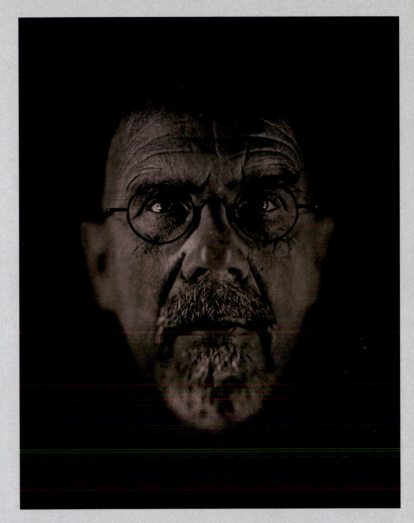

1.23

Title: Self-Portrait, 2000

Photographer: Chuck Close

'In 1840 virtually everything that I love about photography was already there.' Even in reproduction the intensity and detail of this image is evident. Close achieves this through the use of daguerreotype plates, which produce 'the deepest most velvety blacks to the brightest highlight, which is light bouncing off the highly polished silver surface, combined with modern strobe lights: the equivalent of two minutes of full sunlight in a split second'.

For the most part, Close has treated photography as a tool, a means to an end: a painting. However, in 1999 Close collaborated with Jerry Spagnoli, one of the few contemporary practitioners with the requisite knowledge and skills to make daguerreotypes as images in their own right. The process is complicated, dangerous (the mercury vapour used for developing the image is poisonous) and vulnerable to failure. The need for long exposure times, due to the process's relatively slow sensitivity to light, is counteracted by subjecting sitters to a blinding, even scorching, high-intensity strobe light. This allows the instantaneous capture of an image of outstanding, and unforgiving, detail and clarity.

The images have deep blacks contrasting with bright highlights; Close focuses the camera on the eyes of the subject and uses an extremely shallow depth of field so that even the tip of the nose is slightly out of focus. The effect is intimate and intense: the subject seems to look directly and unflinchingly at the viewer. This is particularly striking in the portrait of Cindy Sherman where the slight angle of her head to the camera means that only one eye is in sharp focus.

The small (165 x 216 mm), unique daguerreotypes are exhibited in protective cases. Close also makes prints, from digital scans, which are enlarged (e.g. to 406 x 508 mm) as well as translated into enormous tapestries (2007 x 2616 mm) woven on digitally driven electronic looms. Thus, the oldest photographic technology is married to the newest.

1.24

Title: Cindy Sherman, 2000

Photographer: Chuck Close

Cindy Sherman, famous as a photographer herself, and famous, too, for appearing in her own photographs in a bewildering array of guises, is here subjected to Close's intense scrutiny. The extremely shallow focus on Sherman's eye draws us into her own penetrating gaze.

Synopsis

This case study has focused on an example of the contemporary application of old photographic technology.

- Although rooted in natural optical and chemical phenomena, every photographic system produces a distinctive character of representation.
- The world viewed through the lens of a camera, and represented in a photograph, is different to how it is seen in natural vision.

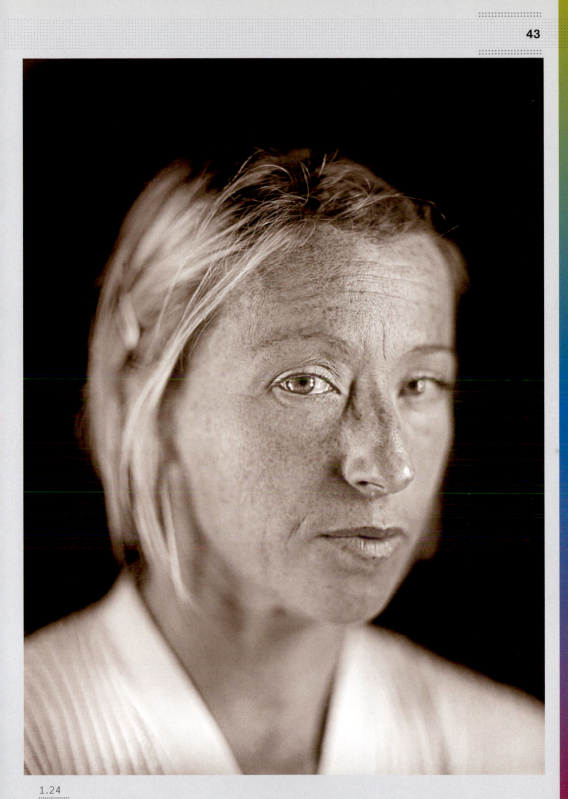

1.24

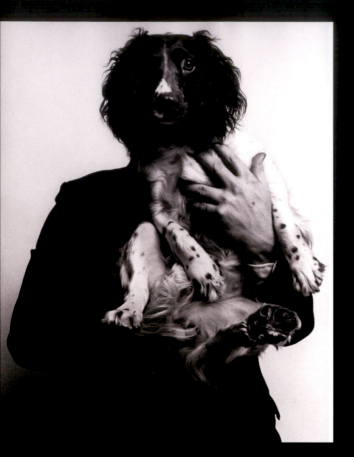

2.1

2.1

Title: It's a dog's life, 1980

Photographer: John Ingledew

The double take is momentary, but even after the brain has worked out that this is a picture of a man holding a dog, the eyes insist on seeing a 'dog-man'.

Reading the signs

Imagine you woke up as a dog. Other dogs check you out. You can't understand a thing they bark at you; and some of their behaviour seems distinctly odd: why do they keep sniffing lamp posts? They don't seem to understand anything you say, and you don't understand them. You need to learn to speak dog…

This chapter looks at one approach to how we make sense of the world: through an active process of semiotics – the science of signs. The thought experiment of imagining yourself as being outside of human culture – as a dog or an alien – and seeing it from a different perspective is one way to draw attention to the highly complex system of communications we have evolved. It also makes us realize that meanings we may take to be obvious, or natural, or simply 'common sense', are actually the product of a particular system of representation and thinking.

Semiotics is one method of interpreting the world and accounting for the production of meaning by treating everything as a collection of signs to be read. Just as we read words on a page – by giving meaning to the graphic marks (letters), to combinations of letters (words) and to the combination and sequence of words – so, too, we 'read' signs in the world around us: pictures, faces, bodies, clothes, music, even smells. In short, this approach proposes that we treat everything as a 'text' to be read – including, ourselves, photographs and even dogs.

This chapter will introduce the key principles and vocabulary of semiotics together with its practical application to photographs.

We learn to read and speak through a process of repetition and recognition of patterns of shapes and sounds: it can seem as though things in the world come already named and all we have to do is to discover and learn that name. However, if we learn a second language it quickly becomes very obvious that the names of things are not 'natural' – 'dog' in English may, elsewhere, be rendered as *chien*, *perro*, 狗, 犬 or الكلب. What is also clear is that if you don't speak the language – or know the code – words revert to what they fundamentally are: abstract marks and sounds – signs. The speaker might as well be barking.

What follows from this recognition is that rather than 'finding' meaning in the world, we actually 'give' meaning to the world and its contents through language. Arguably, the world is simply full of meaningless things – words and things mean what they mean as a result of the way that we look at them and use them. Making a photograph is a way of giving meaning.

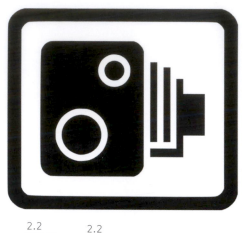

2.2

2.2

Title: Speed camera

In the UK this roadside sign signifies the presence of speed cameras and is a reminder not to exceed the limit. The image is instantly readable as representing a camera – yet it does not actually resemble a camera most people would be familiar with. The sign is part iconic and part symbolic.

2.3

Making meanings

It doesn't follow from the idea that we 'give' meaning to the objects in the world, that anything can mean anything. Communication is a social process and depends upon a degree of mutual understanding.

Nevertheless, it is possible to change the meaning of things. The artist Marcel Duchamp, provided one of the most notorious examples of this when in 1917 he designated a shop-bought urinal 'Fountain' and declared it to be a work of art. The designations 'urinal' and 'work of art' seem to be mutually exclusive. However, although the object retains the physical form of a urinal it no longer has that function so, arguably, it is now not a urinal; and since the context for viewing the object is now in an art gallery – its acceptance there being the result of a consensus of opinion within part of the art community – then the object *can* be considered as a work of art. However, this idea can also be disputed.

On the other hand, photographs seem to work very differently to words, and indeed, to objects. Isn't a photograph rather like a window onto the world, simply showing the viewer what was in front of the camera? If the photograph, is regarded as a record of the scene before the photographer then its meaning might seem to be identical with that of the scene. The photograph seems to offer a statement of proof, like a witness statement.

However, while a photograph might be said to show faithfully what a scene 'looked' like at a given moment – albeit, from a particular point of view, as refracted through a particular lens and subject to the choices of framing, exposure and processing, and rendered as a two-dimesional image on paper or screen – what the photograph 'means' is another matter entirely. Semiotics is an analytical method that opens up the process of interpreting photographs.

2.3

Title: Untitled, 2010

Photographer: Trudie Ballantyne

The directness of the iconic, visual representation ensures that the meaning of this sign is conveyed without any need for words.

Language is an astonishing facility: it offers the opportunity to think, express and communicate extraordinarily subtle and complex feelings and ideas. A whole universe of ideas and associations can be collapsed into the unity of a single sentence which, in English at least, comprises no more than the combination and variations of 26 graphic marks and a repertoire of sounds corresponding to those combinations.

The effectiveness and expressivity of words can be amplified by a whole range of factors; coherence and clarity are partly governed by the rules of grammar, which provide a framework for comprehensibility; the choice of words in combination can give colour and emphasis; in speech, intonation gives expression, as size, style and colour of lettering do in print.

The art of using language most effectively is called 'rhetoric'; and this is an idea that lends itself very readily to the art of designing images. In painting or graphic design, it is obvious that particular combinations of colour and the style of drawing are fundamental to the work's effectiveness.

The same is true for photography. Apart from the very choice of subject, there is a syntax, or grammar applied to the image. The photographer has the opportunity to make a series of decisions, which may enhance or encourage a particular reading: the choice of black and white or colour; how to compose the image within the frame – what to include and, equally important, what to exclude; what is the angle of view; what is in focus; and so on. To some extent, every photograph is the product of choices and decisions. Of course, the photographer has the opportunity to edit the resulting picture and, just as a poet might take liberties with the conventional ordering of words for greater expressivity, so too can the photographer reorder the form and contents of the picture.

Given this account, it might be better to think of the process not so much as taking photographs (as if the image was preformed, just waiting for us to collect it), but as making or constructing them.

2.4

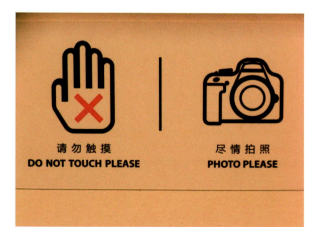

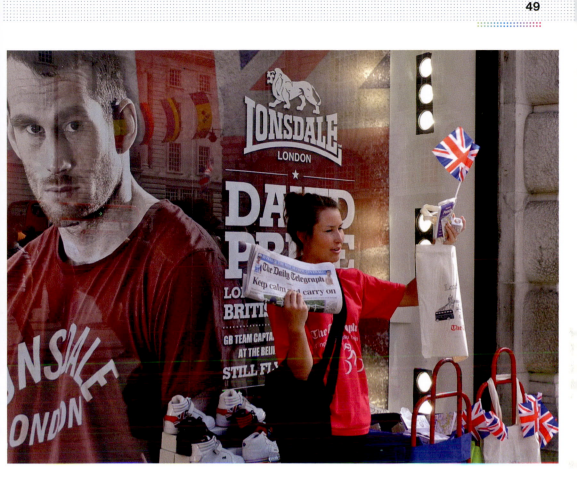

2.5

2.5

Title: Keep calm and carry on, 2012

Photographer: Joanna Casey

The newspaper's advice to 'keep calm' seems ironic within the visual noise of words, signs and symbols jostling for attention. The layers of space – the 'real' space of the woman, the two-dimensional space of the image of the man, and the reflected space of the street in the window – all make for a complicated yet readable image.

Semiotics (alternatively referred to as 'semiology') has its historical roots in the work of Swiss linguist Ferdinand de Saussure, whose lectures were first published in 1916, and the near contemporary, but independent work of American philosopher Charles Sanders Peirce. It was not until the 1960s and 1970s when, through the writings of Roland Barthes and others, the method began to have widespread academic application. Today, it has become a fundamental element in the critical and analytical vocabulary of visual culture, most obviously perhaps in the reading of advertisements.

The method has evolved from one of 'decoding', or assuming that meanings were fixed, to one of interpretation – recognizing that meanings are actively produced through the process of reading. Meanings are made, not found.

We use signs to give meaning to things; not just in the literal sense of using words and symbols to give names to things, but in the sense that everything can be given a sign value: objects, gestures, appearance and images. We ourselves function as signs and everything we do and say is understood through the interpretation of those signs. In his collection of essays, *Mythologies* (1993), Roland Barthes showed how familiar and commonplace aspects of culture (such as wine, Citroën cars, steak and chips, advertisements for washing powder) can be understood to encode and signify a whole range of beliefs and social relations.

The following sections examine the technical language of semiotics and the operation of the sign.

Roland Barthes (1915–1980)

French critic and theorist, Barthes was a key contributor to the development of semiotics, drawing on the earlier work of Ferdinand de Saussure (1857–1913). His 1957 essays, collected in *Mythologies* (1993), applied the semiotic method to an engaging variety of examples of popular culture. The semiotics of photography are examined in 'Rhetoric of the Image' and 'The Photographic Message', which can be found in *Image-Music-Text* (1977). Barthes took a more personal and meditative approach to photography in *Camera Lucida* (1993).

2.6

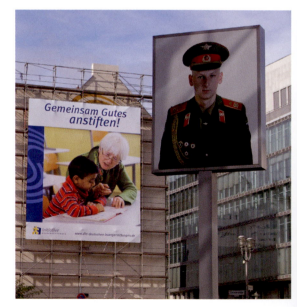

Signifiers and signifieds

A sign, by definition, refers to something other than itself.

A sign comprises two elements: the signifier – its physical form, such as a word (spoken or written), an image, a gesture, or an object; and the signified – the mental concept triggered by the signifier. The letters D – O – G, and the form pictured in image 2.7 are signifiers that trigger the mental idea of a dog. To be sure, in the photograph a particular dog has been represented, but it is no more physically present on the page, or in your mind, than the dog signified by the letters.

An actual dog is here termed the 'referent' – the thing that the sign as a whole stands for, but which is not physically present. Even when a dog is in front of you, it can function as a sign: it may signify 'keep out', or 'stroke me'; its growls and tail-wagging are signifiers for us to interpret.

Different sorts of signs can be identified, distinguished by the particular relationship of signifier to signified: these are arbitrary or symbolic, indexical and iconic signs.

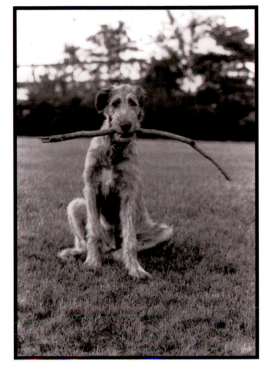

2.7

2.6

Title: New World (Checkpoint Charlie, Berlin), 2009

Photographer: Emilia Nylén

The uniform denotes the central figure is a soldier; the formality of the image and its elevation connote some importance. In contrasting representational style, the image of a woman and child connote teacher and student. The juxtaposition of the images in the photograph sets up a symbolic dialogue of values.

2.7

Title: New Jersey, 1971

Photographer: Elliott Erwitt

Erwitt's portraits of dogs present them as disarmingly expressive: we see the dog's physical attributes – eyes, ears, mouth, set of the head – and read these as coded signifiers of character. Almost as if the dog were human!

Arbitrary, iconic and indexical signs

The arbitrary or symbolic sign is one in which there is no natural connection between signifier and signified. Most spoken and written language comprises arbitrary signifiers – the sounds and graphic marks D – O – G symbolize the animal, but have no natural connection with it and must be learned. The colours of traffic lights are similarly arbitrary – we have decided, and agreed, that red symbolizes 'stop' – but we could equally have chosen blue.

Indexical signifiers are ones that are produced by that which they signify. For example, smoke is produced by fire and so signifies it indexically. Similarly, a footprint indexically signifies the person or animal whose foot made it; a bark indexically signifies the presence of a dog.

Photographs function as indexical signifiers in that they are produced by the effects of light on a light-sensitive material. The image in a photograph has a direct causal link with the scene that existed in front of the camera at the moment of exposure. It is this necessary relationship that gives rise to the popular idea that the camera never lies.

Iconic signifiers are those which resemble what they signify. For example, a drawing that recognizably represents its subject is iconic. Photographic images are, of course, iconic: we read the contents of photographs in terms of the resemblance of the two-dimensional image to the scene represented.

It should be immediately apparent that a photograph may combine all these types of signs: the photograph itself can be seen as indexical (a trace of light) and may include other indexical signs within the image (such as smoke, which may be indexical both of fire and wind); recognizable figures and objects in the image are iconic, while any words included in the scene would be arbitrary or symbolic.

2.8

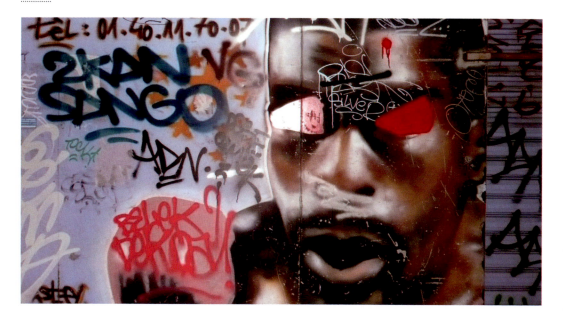

Denotation and connotation

Everyone who looks at a photograph will literally see the same thing. In the case of image 2.7, everyone will see the same graphic pattern, and most will recognize the creature signified as one classified as 'dog'. This is denotation, the literal meaning of a signifier, and it is the first stage of reading.

However, although we can agree that the animal signified is a dog, how we then interpret the meaning of 'dog' (beyond the classification of a particular sort of mammal) will be subject to a range of variables. Some may be reminded of a loved pet and project their memories and affection onto this representation; those who have been bitten or chased by such a dog may project their dislike or fear onto it; those with expert knowledge will identify the breed and attribute associated characteristics onto the representation. The design of the picture lends itself to anthropomorphic interpretation: we project human characteristics onto the dog – we read its 'expression'.

This is connotation – the associated ideas that are suggested by the image, but which are not explicitly denoted. Individual and subjective experience, knowledge, taste and emotion will all contribute to the particular associations. Nevertheless, although we are all individuals, we are reasonably predictable in many respects, and so a skilled writer, artist, copywriter or photographer can encourage or nudge us towards a particular response.

Consider, for example an advertisement for perfume: how do you represent an invisible commodity? Typically, such an advertisement will include a bottle, a person and a brand name; the person may be a celebrity. These elements are denoted, but the actual commodity, a fragrance, cannot be visually denoted. The visual elements – words, colours, faces, bodies – will be organized to connote pleasure, glamour, and sexiness, which will then be associated with the product.

2.8

Title: Paris graffitti, 2012

Photographer: Richard Salkeld

The full range of signifiers is here: the lines of spray paint and the graphic marks are indexical signifiers, traces of the gestures that made them; the scripts are arbitrary signifiers, readable with the requisite knowledge; the star shapes are symbolic signifiers; the face, recognizable as such, is an iconic signifier; and the whole image, being a photograph (though its form is effaced) is an indexical signifier, existing as a trace of the light reflected from the wall.

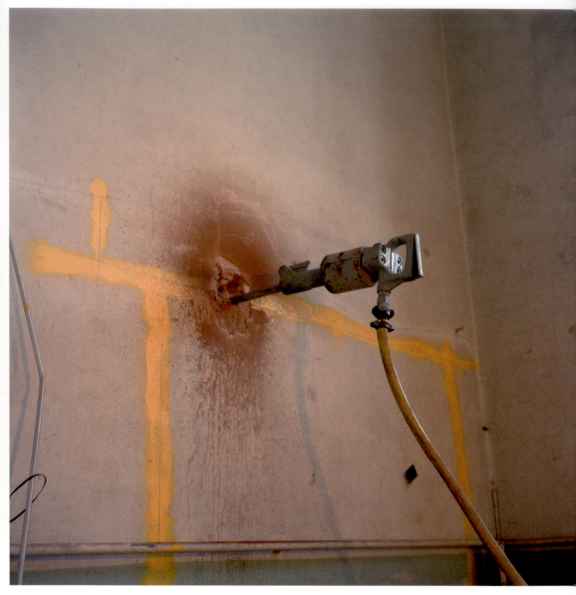

2.9

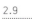

Codes, context and genre

Words and images can be slippery things; we live in a world in which we are bombarded by information, with words and images competing for our attention. This would all be potentially confusing and meaningless babble if we had no means of sorting and filtering the information. However, a quick flick through a magazine, or browsing through TV channels, or surfing the net, will demonstrate that we are able to discriminate very quickly between advertisements, fiction, news, gossip and so on. We are able to do this because the information is generally coded through conventions of language, form and style to signal its category.

'Genre' is a term used to indicate a particular style or category of communication. In relation to photography, this might be portrait, documentary, landscape, fashion and so on. Typically, a genre classification will point to conventions associated with the history or ethics of that style – not for the purpose of laying down rules, but for facilitating coherence; however, it is certainly true that slavish adherence to conventions may produce boring and predictable results and that the most stimulating work will often play with, or break, those conventions.

It is important to be able to distinguish between, for example, advertisement and documentary. Sometimes, it is not the structure of the image itself that signals the genre, but the context in which it appears; the way it is 'framed'. Seen as a portrait, a photograph might be judged in relation to its representation of character; but the same photograph could be used for an advertisement to give personality to a product; or it could be used to illustrate a feature article about particular sorts of people; or it might be exhibited in an art gallery and admired for its aesthetic qualities.

2.9

Title: Gainsborough Studios, 2000

Photographer: Peter Marlow

The title gives a clue, but the image is hard to read. Is it simply technical documentation of construction work? Why has the drill been left in the wall? A studio where films by Alfred Hitchcock were made is being converted for other uses. The information animates the image with associations, which may be both sinister and sexual.

Pictures and text; pictures *as* texts

It is relatively rare to encounter a photograph without some accompanying words, even if it is only a caption. The semiotic approach proposes that we treat photographs as texts; that is, as a collection of signifiers to be read and interpreted. However, given that the word 'text' is more familiarly used to denote the words that might accompany a picture rather than the picture itself, this can at first seem a little confusing. Nevertheless, the relationship between words and pictures is hugely important.

Because of a photograph's iconic nature (its resemblance to what it represents), *what* the photograph shows often appears as self-evident. Nevertheless, that instant recognition is immediately articulated in terms of names, labels and descriptions. However, what the photograph *means* remains potentially ambiguous and could spin off in many directions. Roland Barthes termed the photograph's capacity for generating multiple meanings 'polysemy'.

In *Rhetoric of the Image* (1964) Roland Barthes explains how the potential for the meanings of an image to float off in any direction can be 'anchored' by words: captions, advertising copy, accompanying articles, gallery labels – all of these function to tell the viewer more about what they are looking at. People and places are named, contexts are identified – the viewer is directed towards receiving a specific message.

However, words are signifiers, too, and do not simply denote what is in the picture, but will connote a further set of associations; words may not just accompany a photograph, but they might also be a part of the picture, either part of the photographed subject or written onto/scratched into the surface of the photographic print. In the latter case, the effect may be to draw attention to the photograph as a material object, as a sign in its own right.

2.10
Title: *from* 'The Nursing Home' series, 1985

Photographer: Jim Goldberg

By inviting his subjects to write a response directly onto his pictures of them, Goldberg reveals the slippage between appearance and reality: 'We look like we are friends I never talk to him We have nothing to say There is nothing to say We aren't like this picture'. The choice of words and their handwritten form enrich and modify the reading of the image.

2.10

WE LOOK LIKE WE ARE FRIENDS
I NEVER TALK TO HIM
WE HAVE NOTHING IN COMMON
THERE IS NOTHING TO SAY

WE ARENT LIKE THE PICTURE

John Malson

If understanding the world was simply a matter of learning the names of things, life would be very different from the complex one we all know. Understanding the world depends upon how you look at it, your point of view. Differences of opinion can, in part, be put down to personal experience and individual taste and character, but more fundamental differences arise from the very frameworks of our thinking and understanding. Conversely, the smooth running of day-to-day affairs can be attributed to broad levels of consensus arising from shared frameworks of thinking.

These frameworks, the sets of beliefs, ideas and practices that underpin our daily lives and shape our understanding, can be termed 'ideologies'. The term itself is problematic, but useful. It is problematic because it is often used negatively to denote a 'misguided' way of thinking, which deviates from 'normal', common-sense attitudes, and may thus be used to denigrate an alternative view and, ironically, to disguise the fact that the 'normal' view is itself ideological. The term is useful because it helps to account for particular practices and interpretations, and can be employed in both the construction of images and their analysis.

It is perhaps helpful to remember that the very apparatus of photography offers itself as a metaphor for ways of seeing – the camera offers a 'point of view'.

2.11

Title: *from Suburbia*, 1972

Photographer: Bill Owens

Owens shot the pictures for *Suburbia* in Livermore, California, visiting the district every Saturday for a year. He interacted with the residents and printed their observations under the pictures, allowing them to reveal their own values and beliefs, as in this example: 'We're really happy. Our kids are healthy, we eat good food, and we have a really nice home'.

2.12

Title: Mother serving birthday cake to children, c. 1970s

Photographer: H. Armstrong Jones

The precisely controlled colour tones and stilted perfection lend an air of unreality to this image. The obvious artificiality and datedness of the picture – its lack of fit to contemporary reality – help to reveal it as coded to relay an ideological message promoting a very particular set of family values.

2.11

2.12

LE NAUFRAGE
DE RIVA·BELLA
•
Les enquêteurs recherchent
les responsabilités et
revivent par la photo les
dix minutes d'horreur de

LA TRAGÉDIE
DU MANS

LES NUITS DE L'ARMÉE
Le petit Diouf est venu de Ouagadougou
avec ses camarades, enfants de troupes
d'A.O.F., pour ouvrir le fantastique
spectacle que l'Armée française présente
au Palais des Sports cette semaine.

2.13

Encoding ideology

Roland Barthes provided a very clear example of the encoding of ideology in images in his analysis of a *Paris Match* magazine cover in 1955. The magazine showed a young, black soldier saluting. Barthes pointed out what is denoted – what is literally present in the photograph: the boy, his costume, and his gesture. The costume suggests a uniform, the gesture a salute; both of these things are signifiers in their own right, connoting military service and loyalty. Barthes then argued that there is another 'message' wrapped up into this image which is, as he put it: *France is a great empire, that all her sons, without any colour discrimination, faithfully serve under her flag.*

It is important to understand that such an ideological message is neither explicitly stated in the image, nor need it be consciously read; indeed, it can be argued that the operations of ideology are largely unconscious – taken for granted.

2.13

Title: Cover of *Paris Match*, No. 326, 25 June–2 July 1955

Source: *Paris Match*

Roland Barthes' reading of this image (in *Mythologies*, first published in 1957) proposes that within the obvious meaning (a young black boy, in uniform, saluting) is enfolded an ideological message affirming that France is without racial discrimination.

Common sense – seeing the obvious

Obviously, you don't need to study semiotics to understand a photograph – all you need is a bit of common sense…

But where does common sense come from? Generally, it is learned, even if unconsciously, and passed on through education and tradition. It has been argued, for example, by cultural theorist, Stuart Hall, that: *You cannot learn, through common sense, how things are: you can only discover where they fit into the existing scheme of things.* That is to say that the simple familiarity of 'normal' behaviour and social organization obscures the fact that it is the product of ideological structures.

The obvious meaning of an advertisement for a new gadget, for example, may be to focus on its efficiency and stylishness. However, this may obscure the fact that the makers of the product are perhaps dependent upon the exploitation of underpaid labourers working in unsafe conditions to make a profit. That is, one can see the attractions of the product, but you can't see the manufacturing process.

Photography is a medium that tends to flatter to deceive: we can be easily seduced by the appearance of things. One use of semiotic and ideological analysis can be, as cultural theorist Dick Hebdige, put it, *to see through appearance to the real relations which underlie them.*

Intending meaning, fixing meaning

The ideas outlined in this chapter all point to the idea that meanings are slippery and ambiguous. However, this gives richness and creativity to human communications – after all, if they were simply a matter of data input and output, culture would be fatally diminished.

The potential meaning of any photograph, as perceived by the viewers, may exceed, or even contradict, what the maker intended. Indeed, the maker cannot control the readings made by viewers: in effect, the meaning of any image is actually produced by the viewer.

Roland Barthes, in an essay titled *'The Death of the Author'* (1968), challenged the familiar (and 'common sense') idea that the explanation of any example of literature was to be found in the person of the 'author'; but, since the author is not actually present to explain the text to us, we have only our own resources with which to interpret it. By this reasoning, the work is activated through the process of reading and made afresh each time.

Photographers are usually the first 'reader' of their own image and it may well be that they don't know what they have got until they see the results – and this may, of course, diverge from their intentions or expectations.

However, there are circumstances when it is both desirable and necessary to transmit unambiguous information – the road sign needs to say 'stop' or 'go', not 'make your own mind up'; in matters of evidence, we need to be able to trust the facts. Propaganda and advertising aim to persuade action or thought. If advertisements were read entirely subjectively and unpredictably, businesses wouldn't waste substantial budgets on so chancy a process. However, whether they use the vocabulary or not, advertisers generally know their semiotics and understand how to target a particular audience. They can seduce us by juxtaposing suggestive, connotative, images with denoted brands to construct a set of associations that, hopefully, will become fixed in the consumer's mind.

2.14

2.14

Title: Cemetery gates, 2009

Photographer: Richard Salkeld

The original image here was of black cemetery gates reflected in a muddy puddle. By inverting the image and subjecting it to extensive adjustment of colour and brightness a surprising golden glow emerged, giving the image a heavenly connotation. The final image was neither expected nor planned.

Making strange

At the beginning of the chapter, it was suggested that imagining the point of view of a dog might help to give a fresh perspective on some of the habits and conventions which order our lives and which we take for granted. Such a strategy was named 'defamiliarization' or 'making strange' by Viktor Shklovsky, at the time of the Russian Revolution, in 1917.

Aleksandr Rodchenko's 1930 photograph of *Pioneer with Trumpet*, seen from below his chin, could indeed have been taken from a dog's view; *Woman at the Telephone* (1923), gives us a picture of a woman seen from directly above her head.

Such strategies not only provide unfamiliar views, but also draw attention to the photograph as a photograph – that is as representation constructed by means of a particular technology and thus, a coded message as opposed to the fantasy that we magically see through a photograph, as through a window onto reality.

In truth, some of these particular strategies – the worm's view, the bird's view – have themselves become all too familiar, so that what was once radical can now seem to be a cliché. Nevertheless, the principle of making strange has wide application, whether to grab our attention for the purposes of selling goods, or raising consciousness about social and economic structures.

Perhaps one of the most sustained modern uses of such a strategy was the series of campaigns by Benetton through the 1980s and 1990s. Puzzlingly, and provocatively, the name of this manufacturer of clothing was associated with images signifying a range of social issues and controversies, including AIDS, racism, homosexuality and religion. While there may be debate about the precise meaning, purpose and ethics of such an approach, there is no doubting that the viewer's attention was caught by the disruption of the all too familiar conventions of advertising, and they were forced to think about what they were looking at.

2.15

2.16

2.16

**Title: Posters in the
Benetton store, London, UK, 2012**

Photographer: Chris Ratcliffe

In 2011, Benetton continued its
tradition of campaigns, which have
no obvious connection with the
company's commercial products:
the 'Unhate' posters featured
manipulated photographs of world
leaders of opposing political and
religious conviction, kissing – with
predictably outraged response. In
2012, the 'Unemployee of the Year'
campaign sought to recognize the
plight of the unemployed.

2.15

**Title: Roller coaster, Happy
Valley, Shanghai, China, 2009**

Photographer: Trudie Ballantyne

Ballantyne's imaginative viewpoint
and framing have turned this
fairground structure into a dramatic,
graphic, abstract design.

Case study
Anthony Barrett

Look at the image, opposite, and use semiotics to decode it by identifying the following: what is denoted? What is connoted? What sorts of signs are operating – iconic, indexical, arbitrary and/or symbolic?

What is denoted is what we literally 'see': a man wearing a yellow apron and blue gloves stands against a background of sea and sky; a rope hangs in the air in front and above him; an orange sphere, a small flagpole, blue receptacles containing various materials, and the diagonal line of a pole in the top right corner.

Certain connotations are immediate: the man appears to be on a boat at sea – though we cannot see the actual form of a boat. The man's clothing and posture connote that he is engaged in work and might be fishing – though no actual fish are visible to confirm this.

These meanings are delivered through iconic signifiers: the visual resemblance of the forms to what they represent. However, there are also indexical signifiers here, too. We know that ropes do not simply hang in the air, so its position is explained by the man's hand and posture, which indicate that it has just been thrown – or 'cast' – a term that further connotes fishing.

This might seem to exhaust the reading of the image as straightforward documentation.

However, the triangular composition of forms draws the eye to the loop of rope which seems to hover above the man's head – like a halo. This appearance is entirely accidental, but might trigger biblical associations: …*he saw Simon and Andrew…casting a net into the sea: for they were fishers. And Jesus said unto them, Come ye after me, and I will make you become fishers of men.* (St Mark, 1:12)

In this example the rope can be read simultaneously as iconic (it visually resembles rope), indexical (its position is the result of being thrown), arbitrary (the loop can be declared to be a 'halo') and symbolic (read as a halo, it triggers an allusion to biblical narrative). While this chain of interpretation adds richness to the image it is, of course, not a necessary one: the picture functions satisfactorily simply as an account of a working day in the modern fishing industry.

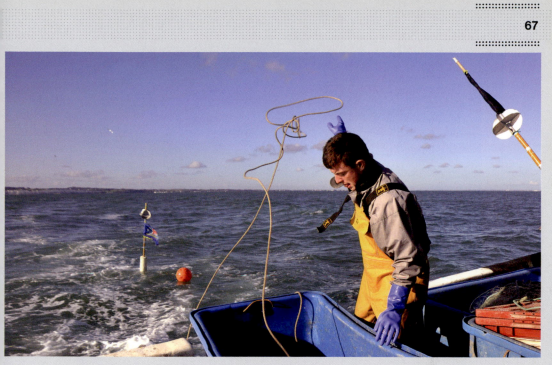

Synopsis

This case study has explored the use of semiotic analysis of a photograph, identifying the key terms and ideas:

- Denotation: the literal and obvious connection between a signifier and what it represents.
- Connotation: the associations linked to what is denoted and how it is understood.
- Iconic signifiers: the visual resemblance of forms in photographs to what they represent.
- Indexical signifiers: signs that are formed by what they represent (a fluttering flag signifies wind).
- Arbitrary signifiers: forms that have no necessary connection with what they signify (the graphic forms of words, or a circle [halo] to signify holiness).
- Symbolic signifiers: a type of arbitrary signifier that carries associations to ideas and beliefs (the religious associations triggered by a halo).

2.17

Title: Casting the gill net, 2009

Photographer: Anthony Barrett

If the aim of documentary photography is to present an honest account of the world, the art lies in rendering the sometimes chaotic, sometimes mundane, flux of reality into not just a readable form, but an engaging one. Here, Barrett's camera has framed and caught a moment in the everyday life of the fisherman made eloquent by the visual organization coupled with connotative richness.

3.1
..............

3.1

Title: The Leaning Tower of Pisa, Italy, 1990 *from* the series 'Small World' (1987–1994)

Photographer: Martin Parr

Seen from the wrong angle these tourists posing to support or push the leaning tower appear ridiculous; only from the right perspectives will each achieve the desired visual effect. Parr's witty photograph brilliantly demonstrates the camera's capacity for blurring the line between truth and illusion.

Truth and lies

Seeing is believing. I saw it with my own eyes. The camera doesn't lie.

Most of us know the difference between reality and illusion, between truth and lies. Or, at least, we think we do. We put considerable faith in the evidence of our own eyes; our grasp on 'reality' depends upon the confidence with which we can distinguish truth from fiction. Ideally, we like to see things for ourselves. But we can't be everywhere at once, and see everything. Photographers across the globe document people and places and witness events on our behalf – but can we trust what their pictures tell us?

From its beginnings the photograph has functioned as evidence, as a truth-bearing document. However, photographs have also been used to create fiction, mislead and to tell lies. Today, the ease with which digital images are routinely adjusted may unsettle our faith in the truthfulness of photography; but perhaps that faith was itself misplaced?

This chapter will address the relationship of a photographic representation to the world it represents and, in particular, consider to what degree a photograph might be said to 'reflect' or 'produce' reality

The 1999 science fiction film *The Matrix* (directed by Andy and Larry Wachowski) proposed a dystopian future in which human beings are confined to a passive life functioning as 'batteries' for intelligent machines; humans are plugged into a computer programme that simulates reality and are unaware of the true nature of their existence. As Morpheus, leader of a group who had escaped the Matrix, asks: *What is 'real'? How do you define 'real'? If you are talking about what you can feel, what you can smell, what you can taste and see, then 'real' is simply electrical signals interpreted by your brain.*

The Matrix is, of course, fiction and no one is likely to be fooled into thinking otherwise. Nevertheless, there is some sense in Morpheus's observation: our grasp on reality is determined by our perceptions. To be sure, there are facts on which we can all agree and which are by definition independent of our individual perceptions; we can broadly agree on what something looks like – albeit under specific conditions. However, appearances can be deceptive. As discussed, in the previous chapter, what things mean, is subject to interpretation. Meanings are not only shaped by the functioning of our perceptual apparatus (the processing of sense data into electrical signals in our brain), but also by the ideological framework and beliefs, which determine our point of view. Photographs are particularly problematic in this respect: we can be seduced into believing that a faithful record of appearances is actually a 'slice of reality'. That realism is the same as reality.

3.2

Title: Keanu Reeves and Hugo Weaving in 'The Matrix', 1999

Source: Warner Brothers

The 'realism' of *The Matrix* relies upon the audience's suspension of disbelief in the face of layers of 'unreality'. Cinematic special effects show us the illusion of humans flying, which is explained as a fictional representation of virtual reality experienced in the fictional world of the film.

A point of view

Look at it my way. Do you see what I mean?

Metaphors of seeing and looking are intrinsic to our conceptualization of understanding. Curiously, they emphasize both the subjective (*in my view*) and the apparently objective statement of revelation (*now I see! Now I understand*). The camera embodies both aspects – every photograph is by definition a point of view, an angle of vision and a moment selected by the photographer. At the same time the resulting picture can be seen as objective proof of the scene witnessed – its truthfulness apparently independent of the photographer.

The value of photojournalism and documentary photography depends upon our faith in the objectivity of the photographer and the evidentiary status of the photograph. Indeed, every day, we look at pictures informing us about the world and broadly accept them as irrefutable evidence of events and phenomena. The fact that we know that photographs can be tampered with and be used to tell lies only reinforces our general faith in the essential truthfulness of photography: if we learn that a 'documentary' photograph has been altered, then we feel cheated; we feel manipulated.

Pictures that purport to tell the truth about events are subject to considerable ethical and philosophical considerations.

3.2

The camera never lies

The Vietnam War (1954–1975) has been described as the 'media' war: images of it were beamed into homes across America and Europe, and published in magazines and newspapers. It has become commonplace to claim that the course of the war was materially affected by the dissemination of images because the 'truth' that they revealed gave the lie to the official stories.

On 1 February 1968, Eddie Adams was in a street in Saigon (Vietnam) and he saw General Nguyên Ngoc Loan raise his pistol to the head of a Vietcong prisoner; as Loan pulled the trigger, Adams pressed the shutter on his camera and produced one of the most iconic images, not just of the war, but of the twentieth century.

The picture was, and remains, profoundly shocking. It is shocking because of the brute fact it so starkly shows. The camera has objectively recorded a real event, a human execution. The fact that the split second exposure (1/500th second) freezes what no human eye could actually perceive does not diminish its truthfulness – if anything, it cements it. There can be no doubting what happened. Adams won a Pulitzer Prize for the picture.

3.3

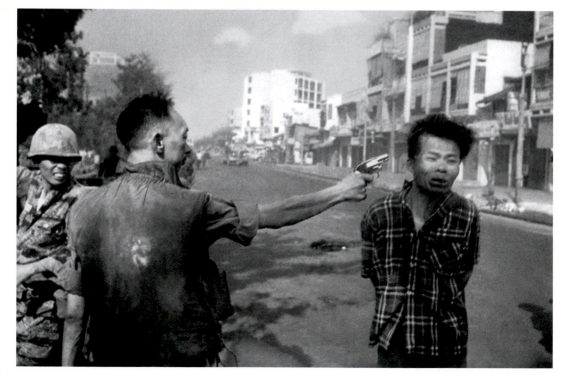

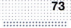

But what can we actually read from the image? What is denoted is very plain: the man on the left of the picture points a gun at the head of the man on the right; it seems, from the expression on the face of the man on the right, that the bullet has just been fired. Those are the facts: they speak eloquently of man's inhumanity to man. But the picture by itself tells us little about the circumstances of, and reasons for, this execution – though the viewer may jump to conclusions sympathetic to the victim.

3.3

Title: General Nguyên Ngoc Loan executing Viet Cong prisoner, Nguyên Văn Lém, Saigon, 1 February, 1968

Photographer: Eddie Adams

Of the many thousands of photographs made during the course of the Vietnam War, this is one of a handful to have acquired lasting significance. The apparently casual brutality of this execution remains as shocking now as it appeared in 1968.

Truth and interpretation

In a filmed interview (*An Unlikely Weapon*, directed by Susan Morgan Cooper, 2008), Eddie Adams talked about his photograph:

I was about five feet away from the prisoner and to my left this guy, I had no idea [who he was], went over and I could see him go for his pistol… I took one frame: that was the instant that he shot him… I didn't even know I got him shooting him… when I see the picture I was not impressed… it's not a great work of art in terms of photography… the light wasn't right… composition was terrible… I still don't understand… why it was so important.

Adams was doing his job: making pictures. A picture such as this comes about through a combination of professional experience, instinctive reaction and luck. As Adams said, he didn't know what he had caught in that split second exposure, nor did he understand the significance of the picture, the meanings it would be given and the effects it would have.

It is only by conextualizing the image, bringing information to it, that the viewer can properly read and interpret it. What the viewer cannot read from the picture is the context.

'[Loan] puts his pistol in his holster… he said, "he killed many of my men and many of your people," and just kept walking… It was a war … I had seen so many people die … it's not nice, but … he shot him, he was a prisoner, and he shot him; I might have done the same thing. The picture destroyed [Loan's] life and that's what bothers me more than anything else… I guess the picture … did good things, but I don't want to hurt people either … it really bothers me; that's not my intention being a photographer, that's not what I want to do.'

Eddie Adams, photographer

But for Adams' picture (and the newsreel of the same incident), the execution of Nguyên Văn Lém by General Nguyên Ngoc Loan would be an unconsidered, now forgotten, routine incident of war; an anonymous statistic in the millions of deaths. However, the representation of the incident has endowed it with significance.

In a lecture examining representation and the media, Professor Stuart Hall argues that *the meaning of an event does not exist until it has been represented… the process of representation enters into events themselves… Representation is constitutive of events.*

In so far as the publication of Adams' picture had an effect not only on the personal life of General Loan but also on the weight of public opinion about the war, and consequently on its course, this would seem to be true. The meanings of the event (beyond that for the individuals concerned) arise directly from its representation in the photograph.

Given this potential, there is a clear ethical responsibility on the part of the photojournalist or documentary photographer: if their pictures purport to record and communicate events occurring around the world, we need to be able to trust that the picture shows, as far as is possible, what we would have seen had we stood in the shoes of the photographer. The picture that most moves is one which persuades us that it is a neutral, disinterested observation; the photographer may be moved, but the mechanical eye of the camera is taken to be indifferent to the scene, and so makes it 'true'.

However, the recognition that photographs can be so powerful is an open invitation to exploit their capacity to affect the viewer and the course of events. Today, that recognition is universal so that much of what we see in media images is effectively a performance enacted to be represented. This can range from the devastating terrorist act; to the work of the spin doctor ensuring that their charge is wearing the right clothes and is in the right company to transmit the desired message to the public; through to the humblest family photograph – 'smile for the camera'.

The photographer who appears to be invisible to their subjects, who catches them apparently unawares (for example, Walker Evans' subway portraits or Richard Billingham's pictures of his family) *seems* to take us closer to reality.

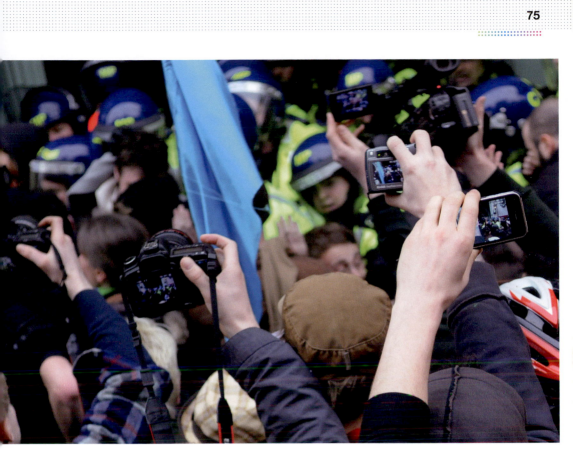

3.4

3.4

Title: London, UK, 26 March 2011

Photographer: 1000 Words

In most images of current events, the photographer is invisible – giving the viewer of the photograph the illusion of a privileged view of the action. By including the photographers in this picture of a clash between protesters and police in London, that illusion is shattered, revealing the photographers as part of the story and not merely neutral observers.

Realism and illusion

Realism is a surprisingly tricky term. On the face of it, it seems to refer straightforwardly to images that convincingly imitate reality. It has been a long-standing assumption that the job of art was to do just that.

Arguably, this spans from the Greek story of the competition between Zeuxis and Parrhasius (the former painted grapes so realistically that they fooled the birds; the latter painted a curtain so convincingly that it fooled his rival) through to the invention of photography. And, indeed, the enduring fascination and usefulness of photography lies precisely in its (apparently) faithful recording of appearances.

However, Realism – a movement associated with nineteenth-century painters, such as Gustave Courbet – shifted the emphasis from mere appearance (which could be rendered convincingly even for wholly idealized or fantastical themes) to representing the truth of experience. Courbet made paintings (such as *A Burial at Ornans*, 1849) which depicted ordinary people in everyday circumstances in informal compositions. (One of the innovations of Realist and Impressionist paintings was the snapshot-like cropping of the image within the frame – a device which signifies spontaneity and realism.)

3.5

Realism and reality

A further complication in the use of the term 'realism' is to emphasize, not just the persuasiveness of the reality of the scene represented, but the reality of the medium itself. While illusionism has been the stock in trade of painters through the ages, modernist art tended to draw attention to the construction of the work itself – the brush marks (indexical marks of the presence of the painter), the flatness of the support: a surface to be looked at rather than an illusionistic window to look through.

Part of the peculiarity of photography is the 'transparency' of the medium: the image is inseparable from the surface (whether viewed as a projection of light or a print), making the illusionism of photography as a window onto reality very compelling. There is no material trace or evidence of the photographer. In purely conventional terms, such a trace would generally be regarded as signifying 'bad' photography – the finger in front of the lens, out of focus subjects, over exposure, off-kilter composition – drawing attention to the process. On the other hand, these could be read as signifying a raw authenticity, honesty and awareness of the picture as a 'real' thing itself, a part of the real world.

3.5

Title: Reflections, 2012

Photographer: Joanna Casey

The photograph as a 'window onto reality' is made complicated here by focusing on an actual window. Instead of looking at reality, the window here reflects a multi-layered collage of colours, forms and signs.. Within the chaos and abstraction, a woman's face looks calmly out at the viewer.

Real pictures

New York, at the turn of the twentieth century, was one of the most crowded places in the world. Migration reached a peak in 1907 when more than a million immigrants passed through Ellis Island and into New York. Whatever expectations the immigrants had, the reality for many was, initially at least, poverty and squalor. Jacob Riis, himself an émigré from Denmark, who arrived in 1870, was appalled by the slum conditions in which so many immigrants lived.

Riis worked initially as journalist, but became determined to campaign for the reform of the living conditions of immigrants by using photographs to illustrate his articles and book, *How the Other Half Lives* (1890).

Riis professed little interest in the 'art' of photography or its technical niceties; however, he was a pioneer in the use of flash light. He and his associates would enter dark rooms at night, ignite a magnesium flare, and capture images of the unsuspecting occupants. By professional standards his pictures were pretty rough (not to mention the ethics of his approach!); but, arguably, this perfectly suited the subject matter: 'bad' photographs expressed the bad conditions. In short, Riis was instinctively practising a form of realism.

3.6

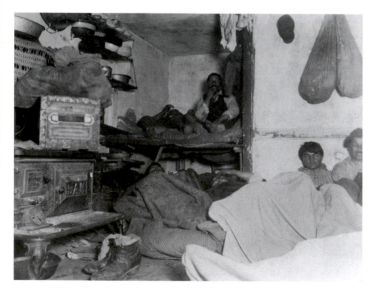

3.6

Title: Five Cents Lodging, Bayard Street, c. 1889

Photographer: Jacob Riis

Riis pioneered the use of flash to literally illuminate the darker corners of the slums of New York. Whether his subjects here were actually taken by surprise or prepared for the event is not absolutely clear. His ethics may be questioned, but his methods were clearly effective.

3.7

Title: Dachau, 2012

Photographer: Matt Frederick

A contemporary photograph, obviously, cannot show anything of the horror associated with Dachau concentration camp between 1933 and 1945. However, the formal composition and tone of Frederick's photograph conveys a quiet dignity, which movingly respects the memory of the millions of victims of Nazism.

Form and content

The relationship of form to content is a fundamental aesthetic issue for all image-makers. On the one hand, the immaculate and 'beautiful' image of tragedy and suffering may seem inappropriate and even offensive; on the other hand, the signifiers of authenticity and immediacy can be simulated and seem false.

Robert Frank's pictures, published as *The Americans* (1958), were made when he secured a grant to photograph all strata of society in the US. Initially, this was received negatively by some, while others saw that he was 'roughing up' a medium that had become too refined and staid, adding realism. Garry Winogrand gave his street pictures a trademark 'tilt', which connoted dynamism and freshness. However, what begins as stylistic innovation can soon become clichéd and imitative.

Style matters – it shapes how a photograph is read.

3.7

The writer A.D. Coleman has argued that *all photographs are fictions, to a far greater extent than we are yet able or willing to acknowledge.* Most photographs, however, disguise the degree to which they are constructed by means of their illusion of transparency.

The discussion so far has emphasized the questions arising from the perceived truthfulness of photography; but as should be apparent, that is only one side of the story. To be sure, a preoccupation with truthfulness has been dominant through much of the history of the medium; but there has been an equally long-standing engagement with the construction of fictional scenarios, of exploiting the pictorial creativity and freedom enjoyed by painters. The realism implicit in the medium gives an extra edge to the resulting pictures – even though the viewer may be perfectly aware that the scenario is a stage set peopled by performers for the purpose of making the photograph; the realism can be very seductive.

This approach is perhaps most obvious and familiar in advertising and fashion photography where the viewer understands the 'game' and takes pleasure in the fantasy and glamour connoted. The game can, however, be quite sophisticated where, for example, to counter a potential palling of artificial glamour, a 'grunge' aesthetic – using derelict locations and/or 'dirty' processing – can impart an ironic glamour and realism.

The fictional mode of photography can be explored through construction and manipulation – both approaches are as old as the medium itself.

3.8

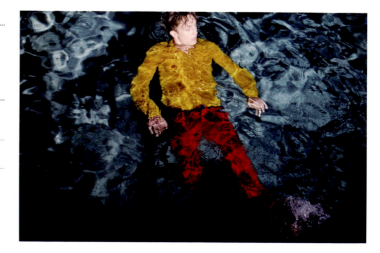

3.8

Title: Fashion shoot at the John Lautner House, Los Angeles, US, 2011

Photographer: Christopher Anderson

The model swims, fully dressed; the location is the pool of a glamorous and futuristic house in California. The gorgeous colour and abstract patterns of the water override concerns about practicality and comfort.

The constructed image

Hippolyte Bayard was one of the pioneers of photography. In 1839, he invented a direct paper positive process and exhibited work prior to the public announcement of the daguerreotype process; politics, however, conspired to deny him the fame that accrued to Daguerre. In 1840, Bayard produced *Self-Portrait as a Drowned Man*, inscribed as follows:

The corpse which you see here is that of M. Bayard, inventor of the process that has just been shown to you…The Government which has been only too generous to Monsieur Daguerre, has said it can do nothing for Monsieur Bayard, and the poor wretch has drowned himself…He has been at the morgue for several days…as you can observe, the face and hands of the gentleman are beginning to decay.

Bayard had not died, but he had produced the first staged photograph.

In 1858, Henry Peach Robinson exhibited *Fading Away*, a work that exemplified the discomfort engendered by the staged image. The picture purports to show a young woman dying, probably from tuberculosis. It is constructed, however, from five separate negatives and features actors. As art historian Stephen Eisenman notes, the picture offended some for its indelicate approach to such a subject, and others for its artificiality, which *was seen as a violation of photographic authenticity.*

3.9

3.9

Title: Fading Away, 1858

Photographer: Henry Peach Robinson

Robinson, a painter turned photographer, enjoyed considerable success with his Pictorialist compositions. He sketched out the plan for his pictures, shot the separate elements, then combined the negatives (five, in this case) to make a single print.

The directorial mode

Henry Peach Robinson's aim had been to make art out of photography. However, his approach to constructing pictures came to be marginalized in early twentieth-century photographic fashion and history, which came to favour the 'straight' photograph.

However, as A.D. Coleman has made clear, the 'directorial mode' merely went underground and re-emerged in the 1970s, notably in the work of Cindy Sherman and Jeff Wall.

In the twenty-first century, the mode has moved to centre stage in, for example, the work of Thomas Demand, who constructs three-dimensional models for the purpose of making a photograph; and Gregory Crewdson, who employs what amounts to a film crew, cast and script to produce still photographs. Typically, such images are large scale and exhibited in galleries, their pleasures and meanings deriving from their equivocal status with respect to photographic 'truth'.

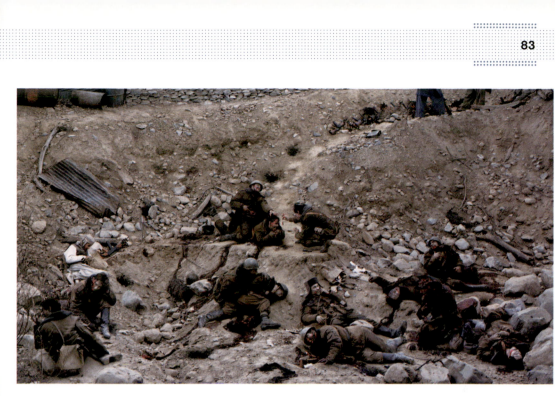

3.11

3.10

Title: Untitled (Brief Encounter) from the series 'Beneath the Roses', 2003–2007

Photographer: Gregory Crewdson

Crewdson is a director of single-frame movies: the pictures are storyboarded, locations secured, lighting crews and actors employed. Shoots may take 11 days. Crewdson even employs a camera operator. The images are edited before being published as limited edition prints, which may be up to seven feet wide.

3.11

Title: Dead Troops Talk (a vision after an ambush of a Red Army patrol, near Moqor, Afghanistan, winter 1986), 1992

Photographer: Jeff Wall

Wall shot a series of tableaux, using actors in a studio, before assembling the final image as a digital montage. Wall frequently makes reference in his images to the history of art. Here, the macabre scene seems to draw on a combination of documentary photography with horror movies. The image is exhibited as a huge transparency in a light box.

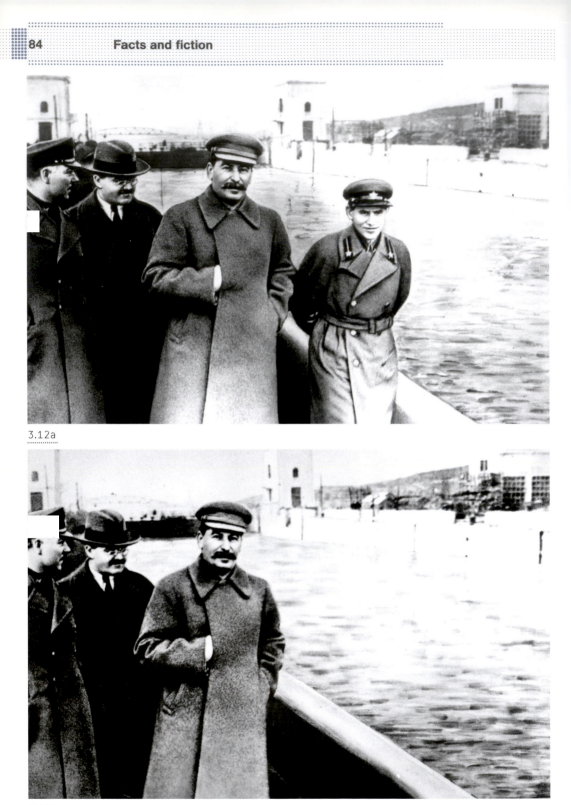

3.12a

3.12b

The manipulated image

The advent of digital photography has raised awareness of the manipulation of images; however, the practice of manipulation is as old as the medium itself.

It would not be unreasonable to argue that manipulation is, to some degree, an unavoidable part of the process itself – from framing to cropping, to selective focus, to lightening, darkening, saturating colours, to posing, re-enacting – every photograph is a manipulation of visual material to produce a picture. Indeed, one could reasonably ask: what would an entirely un-manipulated image look like?

Nevertheless, it is possible to recognize that those elements are understood and taken on trust; of more concern is when images have been modified deliberately to mislead or misinform. Of course, here too, the context is crucial. The 'adjustment' of the relationship of the pyramids to fit more comfortably into the graphic design of a magazine cover is of relatively little consequence. The merging of two separate shots into an 'improved' one representing moments in the theatre of war is altogether more sensitive.

Thus, a composite photograph by Brian Walski, one in which he combined two similar images of what was actually recorded by the camera into one which, while making a more effective composition, shows a scene that could have happened, but was not actually witnessed. Because such a picture exists to feed interpretation, which in turn informs beliefs with potential for political consequences, this is a very serious matter indeed. Walski was sacked from his newspaper.

3.12a–3.12b

Title: Photographs of Voroshilov, Molotov and Stalin with, and without, Nikolai Yezhov, c. 1937–1940

Photographer: Unknown

The manipulation of the lower image is a sinister reflection of the political manipulation of reality: Nikolai Yezhov, Commissar of Water Transport, fell from favour and was shot in 1940. In the manipulated picture, he is made to disappear from history.

The manipulated scene

A very different example of manipulation – of the scene rather than the image – was uncharacteristically deployed by Don McCullin in his 1968 photograph *Body of a North Vietnamese soldier, Hue, Vietnam*. In an interview with Colin Jacobson, McCullin recalled: *there was a kind of insanity in the air, there had been day after day of bloodletting. I came across the body of a young Viet Cong soldier. Some American soldiers were abusing him verbally and stealing his things as souvenirs. It upset me – if this man was brave enough to fight for the freedom of his country, he should have respect. I posed him with his few possessions for a purpose, for a reason, to make a statement... I felt I had a kind of puritanical obligation to give this dead man a voice.*

In the sincere effort to make the most effective photograph – how far would you go?

'All of life presents itself as an immense accumulation of spectacles. Everything that was directly lived has moved away into a representation.'

Guy Debord, writer and theorist

3.13

Title: Death of a loyalist militiaman, Córdoba front, Spain, 1936

Photographer: Robert Capa

Capa famously said, 'if your pictures aren't good enough you're not close enough'. Here, we witness, at close range, the moment of a soldier's death, picked out by a sniper's bullet. A landmark picture in the history of photojournalism, it has, nevertheless, been dogged by suspicions that it was staged.

3.13

Hyperreality

This chapter opened with the assumption that we know the difference between illusion and reality and, of course, in general terms we do. However, it has also been argued here, and in the previous chapter, that reality as experienced in social terms (with respect to beliefs and 'normal' behaviour, and the meanings we give to objects) is a product of language and images – in short, representations. This, it is proposed, is a perfectly natural state of affairs.

However, it has been argued by, for example, Guy Debord in *The Society of the Spectacle* (1967), that our culture is so saturated by images – on television, in advertising, and now the Internet – and that we are so immersed in consumerism, that reality now exists primarily in terms of those images, and the desires and relationships they signify.

These ideas have been further developed by French philosopher Jean Baudrillard (1929–2007), who is associated with the terms 'simulation' and 'hyperreality'. In Baudrillard's view, the signifiers of meaning in our culture are increasingly detached from a reference to physical reality, and instead refer to other signifiers in an endless chain of signification.

This idea is perhaps most easily understood in relation to branding: a brand is merely a name that signifies a set of associations with celebrity, with glamour, with status – with images – which in turn lend meaning and value to a commodity, which may otherwise be indistinguishable from alternative products. Thus, a set of meanings, values and even identities (see Chapter 4) may be constructed entirely out of images. We are invited to model our 'real' selves upon images that are essentially fantasies.

In the hall of mirrors of postmodern culture, we experience, in Baudrillard's words, the loss of the real; images beget images, reality is an endless play of signifiers.

3.14

Title: The corner shop, 2011

Photographer: Alex Bland

Bland's picture presents an enchanted scene: a well-stocked shop has magically materialized in woodland. The hyperreal effect was achieved by painstakingly matching locations and lighting, and layering images. Both shop and woodland were shot just after sunset, with the woodland clearing carefully lit to simulate the effects of light spilling from the shop windows.

3.14

'Real life': street photography

Real life does, of course, go on. Real life is on the streets: that is where things happen. The human story is a social one and it is most plainly visible in public spaces. From the start, photographers were drawn like magnets to the theatre of the street, which provides rich and inexhaustible subject matter.

And, indeed, the subject matter can be regarded as being uniquely matched to the medium. The appeal of street photography is that it gives us a direct (and sometimes amusing or voyeuristic) insight into the real lives of real people; its currency is spontaneity and authenticity.

But street photography also precisely exemplifies the issues discussed in this chapter. For example, Robert Doisneau's 1950 photograph of a couple kissing in a Paris street seems to capture perfectly the romance and spontaneity of young love: a couple lost in each other and blissfully unaware of passers-by and the photographer who has snatched the moment.

Does it change the impact of the picture to learn that it is posed? Many have been disappointed by this revelation for it seems to diminish its truthfulness. Doisneau claimed to have witnessed the couple embracing, but was too diffident to photograph them directly and so asked them to repeat their kiss for his camera.

The key issue here is context and purpose: if the intention is to represent an idea – in this case romance – would a surreptitious and possibly technically awkward shot be superior to a controlled and composed picture of a performance? If in capturing an event, a moment, the ideal shot is missed or fudged, is there a problem in re-enactment for the camera? Obviously, in many circumstances this would be highly inappropriate.

Street photographers have employed both open and covert methods to capture the reality of the street: some melt into the background (Henri Cartier-Bresson) and watch; some engage directly with their subjects (Diane Arbus); some aggressively push their cameras into the faces of strangers (Bruce Gilden); while some set up cameras and lights, and wait for people to enter the frame (Philip-Lorca diCorcia).

'I believe that street photography is central to the issue of photography – that it is purely photographic, whereas the other genres, such as landscape and portrait photography, are a little more applied, more mixed in with the history of painting and other art forms.'

Joel Meyerowitz, street photographer

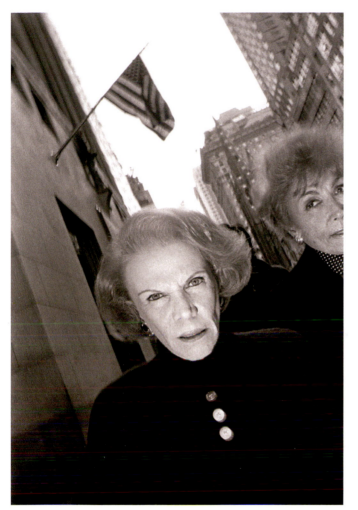

3.15

3.15

Title: Woman walking on Fifth Avenue, New York, US, 1992

Photographer: Bruce Gilden

Gilden's street photography method is aggressive and controversial. Working in a crowd, he will turn with his camera and flash to take pictures inches from strangers' faces. The results are striking and powerfully expressive: at once realistic, and plainly the product of angle, lens and lighting.

Case study
Thomas Hoepker

In choosing New York as their target, the perpetrators of the terrible events of 11 September 2001 ensured that the appalling spectacle of two airliners crashing into the World Trade Center, and the ensuing carnage, achieved unprecedented media coverage. No other city in the world could have guaranteed the immediate attention of more photographers and film crews.

There can be little question that the cumulative evidence of thousands of photographs taken on the day add up to a clear and tragic narrative of death and destruction, and also of many acts of heroism. Many photographs have acquired iconic status, functioning both as dramatic documents of that terrible event, and as powerful symbols of a community responding to attack.

What, however, are we to make of Thomas Hoepker's photograph, *Young people on the Brooklyn waterfront,* September 11, 2001.

Before reading on, note down your interpretation of the scene:

· What is denoted in the picture? State precisely what information the picture literally presents.

· What does the scene tells us about the people represented? What do you think they make of the scene they are witnessing?

· Where, and what, is the truth of this image?

The facts can be stated briefly: five people are sitting in a sunny waterside spot, with a view towards Manhattan Island where the plume of smoke issuing from the World Trade Center is clearly visible. This much can be regarded as objective record. Hoepker's camera has caught the appearance of the scene truthfully.

The people appear relaxed, which, given the context gives rise to an uncomfortable possibility – are they insensitive to the tragedy unfolding before them? As Hoepker, himself, put it: *How could this group of cool-looking young people sit there so relaxed and seemingly untouched by the mother of all catastrophes unfolding in the background?*

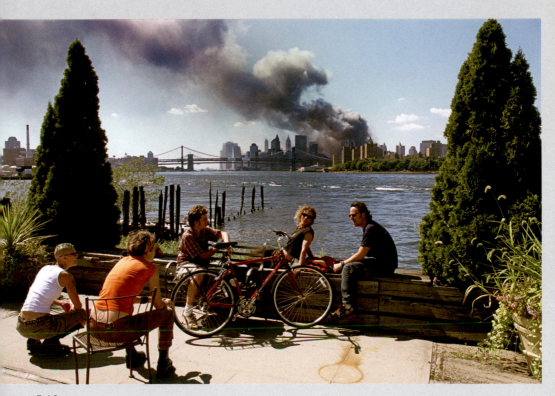

3.16

3.16

**Title: Young people on the
Brooklyn waterfront,
September 11, 2001**

Photographer: Thomas Hoepker

But for the thick plume of smoke
in the background, and the
knowledge of what this signifies,
the scene appears, as Hoepker has
commented, almost idyllic. One of
the recurrent problems in reading
photographs is to square apparently
objective visual evidence
with subjective interpretation
coloured by assumptions and
retrospective knowledge.

Hoepker rejected the image for publication in the immediate aftermath of the event, because it was too 'ambiguous and confusing'. When the picture did surface, nearly five years afterwards, it sparked a debate about its interpretation. Hoepker has described the making of the picture: as a professional photographer, he was trying to make his way to the scene of devastation and glimpsed, en route, *an almost idyllic scene … flowers, cypress trees, a group of young people sitting in the bright sunshine … while the dark, thick plume of smoke was rising in the background. I got out of the car, shot three frames of the seemingly peaceful setting and drove on hastily.* As will be the case in much documentary photography, he didn't speak to the subjects; he didn't ask about their response to the event and he didn't ask permission to photograph them.

The easy interpretation of the group as relaxed and apparently uncaring was forcefully challenged by Walter Sipser, one of the group pictured. He wrote:

A snapshot can make mourners attending a funeral look like they're having a party. Thomas Hoepker took a photograph of my girlfriend and me sitting and talking with strangers against the backdrop of the smoking ruin of the World Trade Center… We were in a profound state of shock and disbelief, like everyone else we encountered that day… [we were] in the middle of an animated discussion about what had just happened.

The reality of the moment, truthfully recorded in the photograph, is that, visible smoke and audible explosions (being indexical signifiers denoting fire and destruction) connoted a terrible accident or attack, along with pain and suffering. However, this reality amounts to a bewildering visual phenomenon, which is yet too raw to be furnished with explanation and meaning: the witnesses of the event could no more be expected to have a full understanding of the reasons for what they are seeing or what its consequences will be than Hoepker (or the viewer of the picture) could know what those witnesses were saying or thinking.

It was only in retrospect that a meaningful account of the day could be pieced together from evidence, of which Hoepker's picture, for all its ambiguity, is one tiny, but valuable, piece.

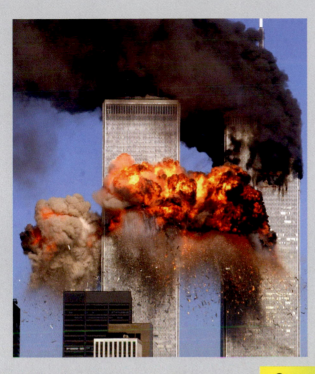

3.17

3.17

**Title: World Trade Center
attacked, September 11, 2011**

Photographer: Spencer Platt

The day after the attack on
The World Trade Center, New
York, the world's media was
dominated by pictures like
this: the scale and horror of
the event is straightforwardly
represented, yet the visual image
is disturbingly reminiscent of a
scene from a disaster movie.

Synopsis

**This case study has used semiotics to
show how the 'truthful' representation
of a scene may, nevertheless, be highly
ambiguous and open to potentially
misleading interpretation.**

- The truth and meaning of an event
 cannot necessarily be grasped simply
 through the act of seeing it;
 explanations come later.

- The truth of a photograph lies in
 showing what a scene looked like, at a
 particular moment, from a particular
 place, recorded by a particular camera
 and lens.

- The interpretation of a photograph (as
 of the event it represents) is subject to
 knowledge and assumptions which
 are external to the image itself.

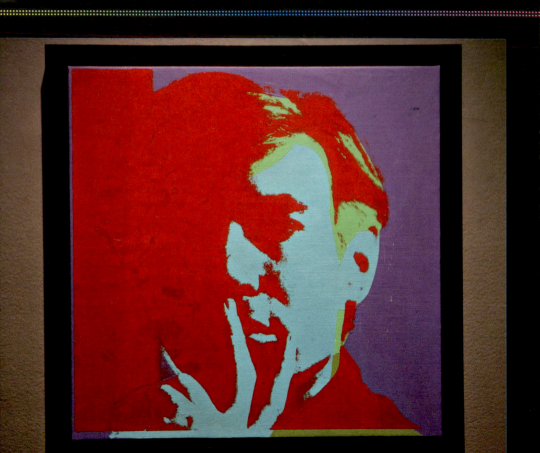

Identity

Pop artist Andy Warhol once said: *If you want to know all about Andy Warhol, just look at the surface: of my paintings and films and me, and there I am. There's nothing behind it.*

Superficially, this seemed to confirm the view of those who saw him as a shallow person and a shallow artist. His portraits of the 1980s – slick and stylish blocks of colour superimposed onto silk screened photographs of celebrities–seemed, at best, to capture the vacuity of an era obsessed with style and image at the expense of deeper meanings. Portraits, surely, should represent the real person? But how, exactly, might this be done? How can a mere image represent the inner world of the person before the camera?

Arguably, Warhol's observation is a witty and ironic recognition of the complexities of the representation of identity. The painting or photograph is literally a flat image, – a sign with nothing behind it. At the same time, it can be seen as a true reflection of who we really are (or who we think we are). It draws attention to the fact that visually, at least, our identity is precisely signified through images – through signs.

This chapter applies the ideas introduced in Chapters 2 and 3 to the matter of individual identity as represented in photographs. What is identity and where is it to be found? What is the relationship of (our) appearance to who we really are?

As Oscar Wilde wrote, in *The Picture of Dorian Gray*, 'It is only shallow people who do not judge by appearances. The true mystery of the world is the visible, not the invisible...'.

The potency and appeal of the photographic portrait is undeniable.

One of the greatest gifts of photography has been to give us the image of people from the past, whether family, friends, celebrities, or ordinary people, and to vividly trigger memories. Whatever else contributes to our individual identities, we are the products of our own histories.

Portraits, of course, have always been made; but predominantly, the subjects of the painted and drawn portrait were the great and the good. The art of portraiture (with notable exceptions, such as Goya) has also, predominantly, been one of flattery and imagination. Portrait photography is no less susceptible to flattery and deception – and yet, who cannot feel that the photograph comes closer to showing how people *really* look and thus, we think, what they are really like? The writer George Bernard Shaw said: *I would willingly exchange every single painting of Christ for one snapshot.*

The historical conventions of portraiture tended to invest all in the single summative image; but as the photographer Aleksandr Rodchenko noted, the ease and speed of photography makes possible the cumulative portrait: *Don't try to capture a man in one synthetic portrait, but rather in lots of snapshots taken at different times and in different circumstances!*

Although such an accumulation may tell a more coherent story of a life, we still tend to look to the face to see who someone really is. We may no longer see the eyes as 'windows to the soul', but they are the most expressive feature of the human face, and we look into them in search of the real person behind them. Yet 'identity' remains elusive and mysterious. Where, and what, one might ask, is identity? How can we see it, know it, represent it?

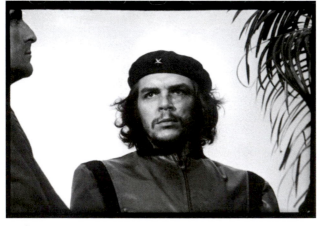

4.2

Title: Che Guevara (at the funeral for victims of an explosion in Cuba), 5 March 1960

Photographer: Alberto Korda

Korda took two frames of Guevara attending a funeral. A cropped version of this picture, with the profile and the palm removed, became one of the most reproduced and recognizable images ever. Shorn of the Marxist revolutionary context from which it came, Guevara's soulful gaze and good looks have been read as symbolic for diverse and often ironically inappropriate causes.

4.2

Reading people/reading pictures

Most of us are expert semioticians in at least one respect: we are very skilled at reading people and may be very aware of how we may be seen, and judged, by others. We are alert, for example, to the signifiers of gender, age, ethnicity, class and character, which we interpret through knowledge and prejudice to assess individuals.

First impressions count for a lot, and most of us would take the trouble to make the best, or the 'right' impression. What is 'right' might be thought of as being 'true to one's self', or, as conforming to the conventions required by circumstances. We might present ourselves differently to a lover, parent, employer or teacher; at home, at work, or in an interview. How we dress, our facial expressions, how we offer ourselves to the scrutiny and observation of others are all elements in a performance designed to communicate, or perhaps to construct an idea of who we are.

This self-consciousness can be clearly evident in the presence of a camera. Point a camera towards a person and, if aware of it, they will typically respond to its gaze: they may turn away and hide their face, they may respond with a smile, a silly face, or a pose. Whether welcoming or resistant, it is a response, above all, to the camera and it is marked by a consciousness of how the subject may look in a photograph.

'I happened on a photograph of Napoleon's youngest brother, Jerome, taken in 1852. And I realized then, with an amazement I have not been able to lessen since: "I am looking at eyes that looked at the Emperor".'

Roland Barthes, philosopher

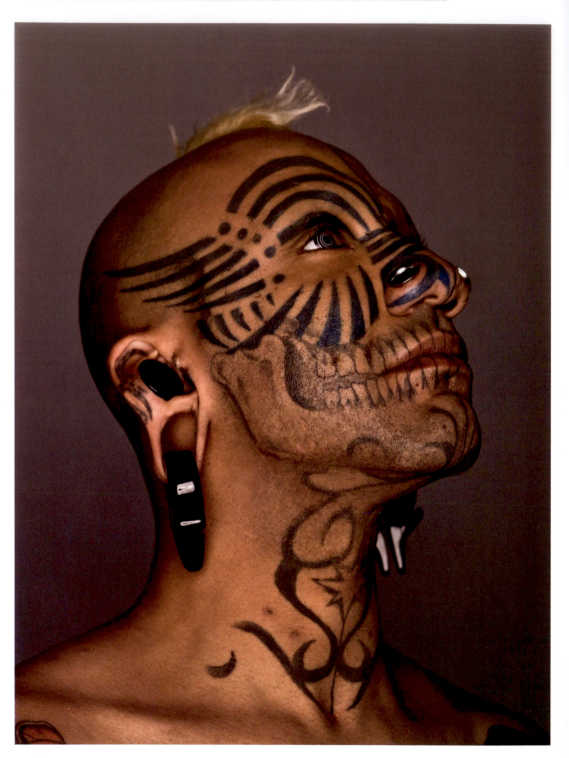

What is identity?

The notion of individual identity is quite slippery. Where and what is it? Does it derive from your genes, from where you were born, from your race, class or education, your gender or sexuality? Or from what you look like? The colour of your skin, the colour of your hair, or eyes, or even the clothes you wear? Of course, it is all these things – together with the story of your life, your experiences and circumstances.

Nevertheless, conventional thinking proposes that whatever our situation, whatever poses we might strike, whatever fashions and styles we may affect, inside us there is our 'real' and 'true' identity; an individual essence which marks us from the cradle to the grave and which the skilled portraitist might strive to recognise, capture and represent.

This is an essentialist notion of identity, which assumes that such an essence defines us and is unchanging. While it is clear that we are all the products of our unique genetic inheritance which defines certain physical attributes, this doesn't quite satisfy the idea of 'character'; it might be argued that our character is intrinsic to our nationality, gender, sexuality, class, ethnicity, even faith. But this is problematic: nationality, for example, is an entirely political notion, and interpretations of the meanings of gender, sexuality, class, ethnicity and faith vary widely.

Constructed identity

An alternative approach, and one which reflects the ideas discussed in chapters 2 and 3, is the 'constructivist' notion of identity. Just as it was proposed that 'things' only have meaning in virtue of their context – the way they are seen in relation to other things, how they are used, what they are called – so, too, it can be argued that identity is not fixed but is relational. Who we are derives from the circumstances of environment, but needn't define us; who we appear to be depends upon how we present ourselves and to whom.

In short, our identity is an on-going (life-long) constructive project, and how we are perceived depends upon the interaction between our performance and the mastery of the conventions of signifiers of identity and the skills with which they are read.

4.3

Title: Tattooed

Photographer:
Kenneth Benjamin Reed

Practices of body decoration and modification have ancient histories and traditions rooted in ritual; however, contemporary Western applications may be more concerned with individualism. Whether this signifies the expression of a unique 'essential' identity, or is evidence of the construction of an identity, remains a matter for debate.

Photographers have used a variety of approaches to signify the identities of their subjects. Broadly these are either 'environmental' portraits – where the subject is presented within a real space and context, which might signify their tastes, activities or circumstances – or studio portraits, where the subject may be accompanied by props, or isolated against a neutral background. Additionally, photographers will use a range of devices intended to relax, animate, surprise or distract the subject in order to contrive a more natural appearance before the camera.

Typically, a portrait is constructed with the conscious (and willing) participation of the subject; but it might be argued that a more authentic portrait is one catching the subject unawares, or unguarded, thus avoiding the self-conscious or instinctive posing for the camera, and preventing the subject from manipulating their own appearance for the purpose of projecting an image. This is manifested in some approaches to street photography where the photographer may be unnoticed by his subjects or may disguise his activity. For example, Walker Evans used a hidden camera; Paul Strand and Helen Levitt used cameras with false lenses, thus fooling the actual subjects, into thinking that they were simply watching the photographer at work. By contrast, the paparazzi's brazen pursuit of the celebrity offstage aims to catch them unprepared, so that we can see the real person behind the mask.

But all of this presupposes that identity is something that can be 'found', revealed and represented and, moreover, that this can be achieved in a single image. However, as suggested above, if identity is thought of as a continually evolving state that presents different faces in different contexts, the single photograph can hardly convey this complexity. At best, the portrait photographer must manage the process in order to construct a representation that connotes a particular idea of identity.

4.4

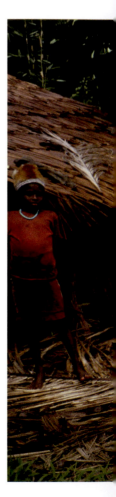

4.4

**Title: Presents
(three Asmat men, three T-shirts,
three presents), 1994**

Photographer: Roy Villevoye

Villevoye's portrait is unsettling
and raises awkward questions
about the representation of identity.
The Asmat people, indigenous to
a remote region of New Guinea,
have sustained ancient cultural
traditions in the face of colonization
and modernity. Here, the men are
lined up as if for an anthropological
study, but wearing T-shirts that
clearly signify Western culture.

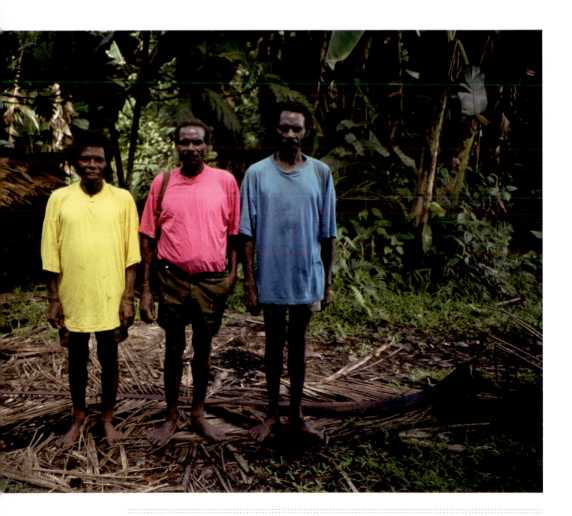

Studio portraits

The conventional notion of the studio portrait takes its cues from the history of portrait painting in which the background would be contrived to either provide context, or simply lend a formal dignity to enhance the image of the sitter. Visitors to a photography portrait studio would typically dress in their Sunday best and be formally posed against a backdrop and supported by an array of props. The limited and impersonal nature of these studios inevitably gives rise to a clichéd and formulaic result. In his portrait studio in Mali, Seydou Keïta's subjects would come not only dressed up in often spectacularly patterned materials, but they would also bring their own props (a radio, a bicycle, a scooter), thus asserting their own sense of their identity in the picture.

The neutral background can be seen in its most stark and dramatic form in the work of Richard Avedon and Irving Penn, both of whom applied their methods to pictures of ordinary people, celebrities and fashion models.

Avedon's 'studio' for the portraits *In the American West* comprised a portable plain white backdrop against which his subjects, ordinary working men and women, would pose. The effect of the backdrop is to isolate them from the distractions of their everyday environment and focus all attention onto the textures of their clothes, faces and bodies in which we read their 'character'.

This isolation tempts us to believe we see the essence of the subject's identity, but at the same time, the effect is to 'make strange' (see Chapter 3). Deprived of a normalizing context, the subjects are made to seem both authentic and exotic. This latter quality is even more evident in Irving Penn's portraits of non-Western subjects, such as New Guinea tribesmen and Moroccan women, in which the contrast between the cool sophistication of the method and the ritual-based costume is startling and disturbing.

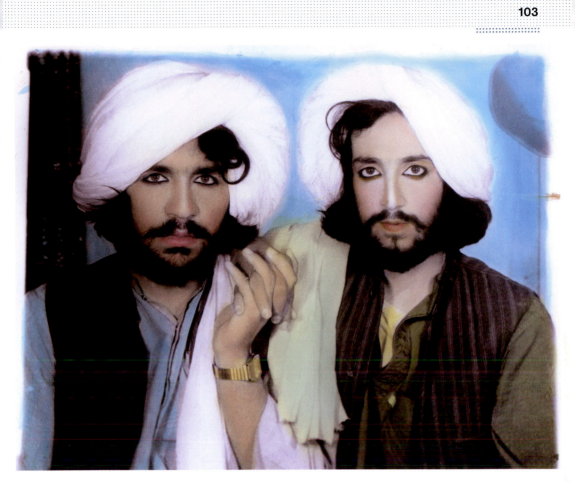

4.5

4.5

Title: Taliban portrait, Kandahar, Afghanistan, 2002

Photographer: © T. Dworzak
Collection/Magnum Photos

In startling contrast to the stereotypes familiar to the West this portrait of Taliban soldiers was made by a studio photographer in Kandahar. It is one of many images found by war photographer Thomas Dworzak after the fall of the Taliban regime in 2002. Retouched by the photographer, the images construct a romantic and intimate portrait of the young men.

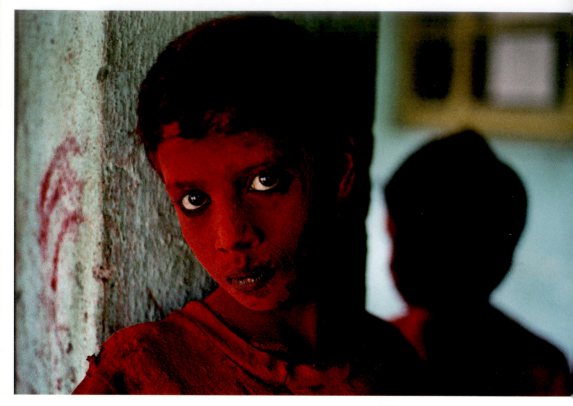

4.6

4.6

Title: Red boy during Holi festival, Mumbai, 1996

Photographer: Steve McCurry

McCurry specializes in street portraits, finding his subjects in their authentic environment. The red boy is participating in the Hindu Holi festival in which faces and bodies are drenched in vivid colour.

Environmental portraits

One of the most ambitious portrait documentary projects was August Sander's *People of the 20th Century*, begun in 1911 and continued with interruptions until the 1950s. Sander set out to document examples of all the social types living and working in the Germany of his time. His approach was highly formal – most subjects are stiffly posed, unsmiling, square to the camera, with their occupation or status signified by their clothes and surroundings. The pictures constitute a fascinating historic document of social types; but although we can read from the subjects' physical appearance and surroundings a great deal of information, they remain inscrutable anonymous types rather than expressive individuals.

Diane Arbus' portraits of New Yorkers in the 1960s bear a superficial resemblance to Sanders' work. Her subjects also appear, face-on, in full consciousness of the camera's gaze; but where Sander's dispassionate and systematic approach establishes a range of stereotypes (peasant, bohemian, middle class) Arbus focuses on very particular types. Her subjects are distinctive in their oddness, that is, they do not fit into conventional stereotypes. The frank stare of her camera seems to expose her subjects as vulnerable outsiders and the pictures have remained enduringly controversial: some see them as profoundly empathetic, celebrating a social diversity that conventional society all too readily marginalizes, while others see Arbus as a cruel exploiter of her subjects' innocence.

The subjective portrait

The emphasis in Sanders' project is objectivity – all our attention is directed to his subjects and the visual information supplied; while we can recognize Sander as organizer of the project and deploying a consistent method, his pictures tell us little about him. Arbus's pictures, on the other hand, are highly subjective: we get a clear insight into her interests and way of seeing the world.

Rineke Dijkstra, an admirer of Arbus, is interested in making portraits of people in states of transition. Her *Beach* portraits show adolescents in bathing costumes with the sea in the background. Caught between childhood and adulthood, and exposed in just their costumes, her subjects betray a touching awkwardness, which seems authentic. More extreme are her portraits of mother with child, minutes after giving birth, and blood-spattered bullfighters fresh from their fights. In each case, the subjects are in such an exhausted and emotionally excited state that they lose their self-consciousness before the camera to allow what Dijkstra calls a 'natural' portrait.

The psychological force of looking and being looked at has been long understood: we are told in *Genesis*, that when Adam and Eve ate the fruit of the Tree of Knowledge, *the eyes of them both were opened, and they knew that they were naked.*

Whatever else one might say about photography, it is definitely about looking. As has already been noted, when a camera lens is turned towards us we feel its gaze, just as we do when a pair of eyes looks at us. This gaze might be met with pleasure or distaste; we might feel admired or perhaps exposed and 'naked'. We become conscious of how we imagine we appear to the other. We, perhaps, adjust our faces and bodies to enhance the signification of an identity that we hope will be read by the other; the other, in turn, is the object of our own gaze and interpretation. Within this simple interaction of looks there can be a complex mix of pleasure and discomfort, desire and power.

That complexity is increased when one considers a photograph: the viewer of a photograph may look at a face that seems to look back at us, but which in fact was looking at the camera or the photographer; though we know this, we may still be seduced into believing that the person in the picture is smiling with pleasure at us.

Looks and gazes

Daniel Chandler, in *Notes on 'The Gaze'*, has helpfully listed the various gazes that can be identified in relation to a photograph. In brief, these are:

- the gaze of the viewer at an image of a person;

- a gaze of one depicted person at another within the world of the image;

- the gaze of a person in the image looking 'out of the frame' as if at the viewer, with associated gestures and postures;

- the *look of the camera*: the way that the camera itself appears to look at the people depicted and, by association, the gaze of the photographer.

A look can challenge, invite or possess. Throughout the ages the power of images has been understood: a face looks at us from a statue, painting or a photograph and we imagine we feel their gaze. The iconoclastic destruction of statues and pictures, or the graffiti assault on a photograph, can seem like a physical assault on the person: the blacking out of eyes to protect identity seems like an act of blinding. On the other hand, we can fall in love with the person we imagine to be smiling seductively at us.

4.7

4.7

Title: Watching me, watching you, 2012

Photographer: Joanna Casey

The geometry of gazes is mapped out here: the boy with the camera looks out of the picture frame; he is looked at by the boys on the left. The boy on the right looks directly at the photographer (and thus, it seems, at the viewer of the photograph), who looks at all of them.

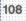

The gendered gaze

Sex, gender and sexuality are clearly fundamental elements of individual identity. Sex refers to the biological characteristics of male and female bodies, gender refers to the cultural differences that are assumed to follow from those biological differences; and sexuality refers to the orientation of sexual desire.

While an essentialist view of gender and sexuality would take them to be fixed characteristics, which are predetermined and naturally follow the given biological identity, the constructivist view would be that these characteristics are shaped by environment, culture and experience.

As French philosopher, Simone de Beauvoir wrote, of female experience: 'One is not born, but rather becomes a woman'. A significant means by which we all learn to become men or women, that is learn to conform to the conventions that define gendered behaviour and appearance in any given culture, is through visual representations. Writers such as John Berger (*Ways of Seeing*, 1972) and Laura Mulvey (*Visual Pleasure and Narrative Cinema*, 1973) have drawn upon psychoanalytical theories of the gaze to argue that a politics of gender underpins visual representations of men and women.

Berger argues that the long established (Western) tradition of representing men as self-sufficient and powerful individuals and women as objects of visual pleasure (principally for men) is so firmly established that the power relationship which it represents appears 'natural' and normal, and that appearance is continually reinforced through repetition.

In *Ways of Seeing*, Berger summarises the relationship as follows: *Men act and women appear. Men look at women. Women watch themselves being looked at. This determines not only most relations between men and women, but also the relation of women to themselves. The surveyor of woman in herself is male: the surveyed female. Thus, she turns herself into an object – and most particularly an object of vision: a sight.*

The concept of the gaze is most potent in relation to the body.

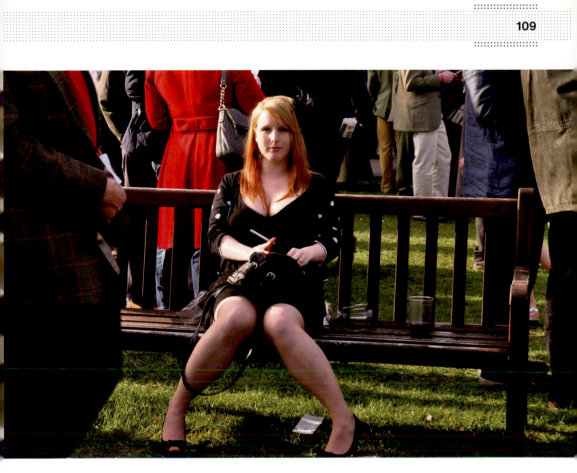

4.8

4.8

Title: Woman at the races, 2012

Photographer: Joanna Casey

This woman, glimpsed by the photographer resting amidst the bustle of the crowd, faces the camera with cool self-possession: her enigmatic gaze, perhaps amused, perhaps challenging, combined with her body language, gives her an electric presence.

To see a person is, literally, to see a body. The bodies we all inhabit can be sources of pleasure and pain, desire and disgust, pride and anxiety.

All cultures have been preoccupied with ways of thinking about and looking at the body. Perhaps, there is no aspect of human social life that is more profoundly and complexly regulated? From the moment a baby is born and declared male or female, that body is subject to a structure of social conventions about how to dress, behave, think and be regarded. To put this in the language of cultural theory, the body is subject to a discursive regime, a set of rules and practices that effectively define 'reality'. To a significant extent, the models of how to dress and present the body are, today, supplied by photographs.

The body can be readily understood as a rich and complex semiotic text. We avidly read and interpret the bodies of those we directly encounter as well as those in media representations. We (mostly) invest considerable effort in our own body management in order to both define ourselves and to signal our identities to others; indeed such investment is encouraged by a vast global industry of fashion and cosmetics.

How the body is represented and for what purpose is a rich source of debate about identity, economics and politics; as Barbara Kruger's 1989 photomontage declares: *Your body is a battleground.*

John Berger (b. 1926)

British writer and critic, Berger's groundbreaking BBC television series and book, *Ways of Seeing* (1972) drew, in part, explicitly on the ideas of Walter Benjamin's essay 'The Work of Art in the Age of Mechanical Reproduction'. *Ways of Seeing* has been hugely influential in making accessible some challenging ideas about the gaze (see pages 106 and 108), feminist analysis of representations of the body, and the role of images in advertising.

4.9

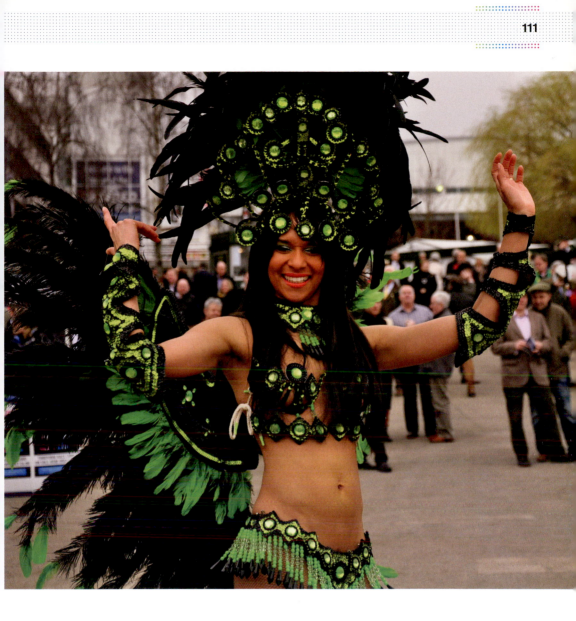

4.9

Title: Brazilian dancer, 2012

Photographer: Joanna Casey

Traditions of dance and costume, the world over, celebrate the body and its energies in joyous and colourful ways. The dancer, here, appears truly spectacular and exotic, seen amongst the crowd in a provincial UK town.

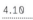

4.10

The ideal body

The ideal body has been celebrated throughout the history of visual culture, from classical Greek sculpture, through Renaissance painting and to our own times. Indeed, to live in the twenty-first century is to be subjected to a relentless parade of media images of beautiful bodies, in advertising, fashion and popular culture. The beautiful body is offered both as an aspiration in its own right as well as lending associated desirability to commodities of all sorts.

The notion of what body shapes and sizes most perfectly signify beauty and desirability, masculinity and femininity, are subject to variations in culture as well as taste and fashion – reinforcing the notion of the 'constructed' body. In the West, for example, women's body shapes have varied from the 'hourglass' shape exemplified by Marilyn Monroe in the 1950s, to the androgynous slenderness of Twiggy in the 1960s. Today, body image in popular culture is marked by a preoccupation with obesity and the contrasting use of size zero models by the fashion industry.

The impossibility of the ideal body as typically represented is not only a reflection of the selectivity of the industry's choices of models, but the additional fact that photographs of beautiful people may be digitally enhanced to render a visual perfection that exceeds nature. This can range from the removal of scars and spots, to adjusting skin colour, to lengthening legs and narrowing waists. Dove's advertising film *Evolution* (2006) entertainingly shows the transition from model in the studio to image on billboard. While, clearly, the adjustment of reality in such a context is not a problem in the way that it would be for photojournalism, nevertheless the practice still raises important ethical questions.

A question worth considering is, exactly whose ideal is the one most typically represented?

4.10

Title: Nude, 2012

Photographer: Elizabeth Ayre

Ayre's elegant female nude, a classic study of light and form, belongs to a long tradition of celebrating ideal human beauty, a tradition that reaches back through the history of Western painting and sculpture, and is continued in photography.

The real body

That there may be a gap between the images of ideal bodies routinely pictured in the media and the shape of actual bodies of ordinary people is no surprise. But the psychological disturbance so caused has become increasingly a matter of concern. It is an issue that goes right to the heart of debates about the power of images to affect individuals and the ethics of photographic representation.

It would seem to be self-evident that advertisements and propaganda have the power to affect people's behaviour, thoughts and actions – and semiotic analysis is one method of revealing how particular images 'speak' to us. However, it does not follow that people are typically mindless, uncritically absorbing and acting upon the messages delivered by the media. As the interpretative model of semiotics suggests, in practice, we are generally active negotiators of meaning rather than passive consumers.

Nevertheless, it is also clear that some people are, for whatever reasons, more vulnerable to manipulation than others – links have been suggested, for example, between the use of underweight models and the occurrence of eating disorders. The lack of representation of particular ethnic and body types can also appear as a form of prejudiced discrimination with consequent damage to individuals' self-esteem.

The evident disconnection between the ideal body, typically represented in advertising, and the 'real' bodies of consumers was cannily exploited by cosmetics company Dove in their 'Campaign for Real Beauty'. Launched in 2004, the advertisements, photographed by Rankin, featured a range of differently sized 'ordinary' women pictured against a blank studio background.

Jodi Bieber, in response to the Dove campaign, made her own series of portraits called 'Real Beauty'. Working in collaboration with genuinely ordinary women in South Africa, she photographed them in their homes, posing as they chose. As Bieber, put it: *the work deals with reality… the shoot created a space in which each woman could explore her own identity in relation to beauty, and live for a couple of hours in an environment of fantasy.*

4.11

Title: Dove campaign

Photographer: Nicholas Bailey

Dove's stated aim was to 'make more women feel beautiful everyday – celebrating diversity and real women by challenging today's stereotypical view of beauty'. The use of non-professional models with a variety of body sizes proved to be a successful marketing strategy – if, perhaps, not quite as radical a challenge to stereotypes as suggested.

new Dove Firming.

As tested on real curves.

Dove Firming Range

4.11

4.12

4.12

Title: Stomach, 2012

Photographer: Nicola Fordyce

The generous expanse of flesh is subtly lit to render the subject voluptuous rather than obese.

4.13

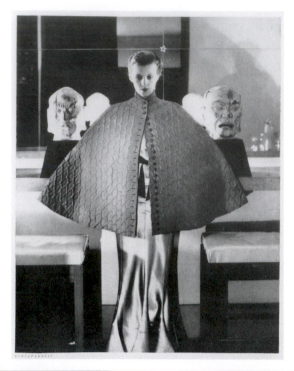

4.13

Title: Model wearing cape by Schiaparelli, for *Harper's Bazaar*, 1933

Photographer: Baron de Meyer
Baron de Mayer was one of the inventors of fashion photography. He was the first staff photographer for *Vogue* (1914) and *Vanity Fair* (1922). His elegant style helped to define the fashion from 1910 onwards, and his celebrity portraits of Njinsky and Josephine Baker captured the glamour of the era.

4.14

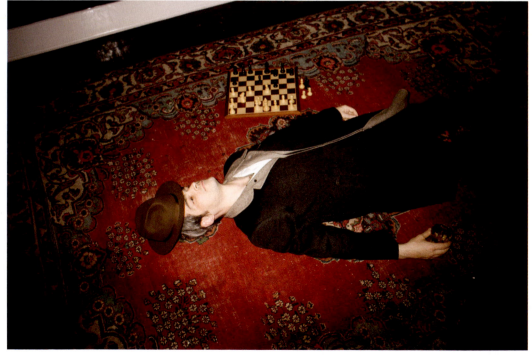

Fantasy and fashion

Clothes protect the body and may signify your status and role in life; fashion, on the other hand, is about self-expression and fantasy, and showing off the body to best effect. The world of fashion has offered, perhaps, the most exciting opportunities for photographers to combine commerce with creativity. Magazines, such as *Vogue* and *Harper's Bazaar,* were transformed by the use of photography in the 1920s and 1930s. Photographers, such as Baron Adolph de Meyer, Edward Steichen and George Hoyningen-Huene, were able to imaginatively develop a visual language of fantasy and seduction that was restricted neither by the hard-nosed demands of product advertisement nor the objectivity of documentary.

Since then, fashion photography has flourished, with innovative photographers consistently pushing the boundaries of taste, style and convention – occasionally courting controversy, which itself generates valuable attention. Free from the obligations of genres, such as photojournalism, to 'tell the truth', fashion photography may nevertheless borrow from them. Steven Meisel, for example, has made fashion shoots that appear to re-present news stories about terrorism, military prisoners and celebrity drug dependence as ironically glamorous fashion spreads.

Fashion and photography were made for each other: both are fundamentally concerned with visual pleasures, with looking. The appeal, of course, is one of identification: viewer are invited to imagine themselves as, or in a relationship with, the model – to experience the admiration, glamour and pleasure connoted by the image.

Reading a fashion photograph may, on one level, be very straightforward – it is, after all, precisely designed to grab our attention. However, analyzing the complex psychology and politics of gender identity and relationships, negotiating the relationship between fantasy and reality, examining the ways in which glamour and desire are signified and commodified, and recognizing the function of the gaze, suggest that, actually, these matters are very complex indeed!

4.14

Title: 'Tank' fashion shoot, 2008

Photographer:
Christopher Anderson

It is the teasing enigma of the picture that draws the viewer's eye: what's the story? The composition seems 'wrong' – the angle of the carpet revealing a corner of floor; the model's right leg out of frame; the whole picture seems centred on the chess board. The desire to 'read' the picture invites the viewer into a fantasy scenario.

Case study
Marc Garanger

Before reading this case study, spend some time looking at the image opposite and then think about these questions:

- What does this photograph represent or express?
- What can you tell about the person in the photograph?
- What do you think was the intended purpose of the photograph?
- Does the picture 'speak for itself'?
- What do you need to know in order to understand the photograph?

Perhaps the only certain thing that can be said of this image is that it is a picture of a woman. This can be deduced from conventional signifiers of gender: the denotations (the literal facts) of clothing, make-up, and facial features, which connote (imply) femaleness. We are very good at reading such signs and the skills with which we interpret the conventions of dress and identity are also used to read a photograph. Of course, just as we may misread a facial expression, or arrange our own features to disguise our feelings, this process is not foolproof – and besides, many such signs are highly ambiguous: typically, we make meanings rather than find them.

So, what of the expression on the face of the woman in the photograph? She seems to be staring directly at us. But of course, she was looking at the camera, or the photographer. It is a challenging look, emphasized by the kohl around the eyes and the set of the mouth. Because we are looking at a photograph, we can stare back at her. The effects of the gaze can be very powerful – the gaze of the camera may be welcomed with a smile, or shunned as intrusive, but in both cases the camera seems to allow us to look in a way that would not otherwise be tolerated.

So who is this woman and why is she not smiling for her portrait?

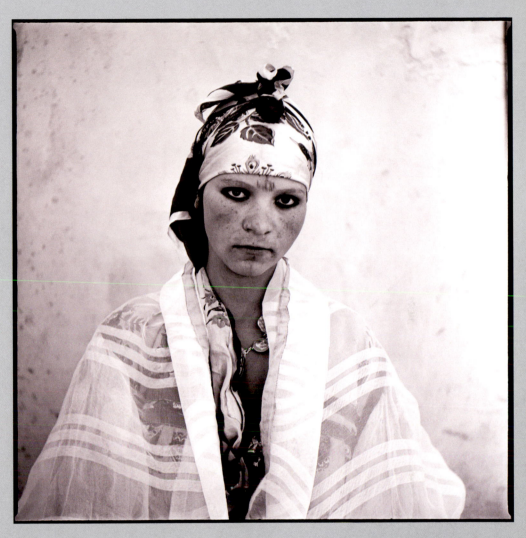

4.15

4.15

Title: *Femmes Algériennes,* 1960

Photographer: Marc Garanger

This woman's challenging gaze makes for a striking portrait; something of her feelings can be read directly from her face, but it is only with knowledge of the circumstances in which the picture was made that the full meaning of her gaze becomes clear.

Does the image speak for itself?

In an interview, the photographer, Marc Garanger, said that 'the image speaks for itself', but is this true? How can an image 'speak for itself'? It is in no way to diminish the eloquence or power of the picture, to acknowledge that, for the viewer to hear it speak, certain information must be available.

All photographs have their origins in a particular moment and circumstance: a context. It is a matter for debate whether it is possible to recover those meanings that were in operation when the photograph was made, or if we can only interpret the photograph in the light of how we see it now. The title tells us that this photograph was taken in 1960, and we might assume that the woman was photographed in Algeria. If the viewer has knowledge of events in Algeria in 1960, other meanings of the photograph may become apparent.

Marc Garanger was a 25-year-old draftee serving in the French army in the Algerian War (1954–62) and was required to photograph the local inhabitants for the production of identity cards. Local Muslim women were forced to queue, to unveil and expose themselves before a stranger and be photographed.

Now the picture speaks loud and clear. The force of that stare is comprehensible: the woman's expression is a signifier of fierce resistance. We are put into an awkward situation – we are looking at the woman in defiance of her wishes; the very existence of the picture is an act of aggression. Arguably, simply by looking at the picture, we are complicit in that violence. The camera is here deployed as an instrument of ideology, discipline and control.

Yet, at the same time we can read the picture as a portrait of great dignity and recognize the sympathy of the photographer.

4.16

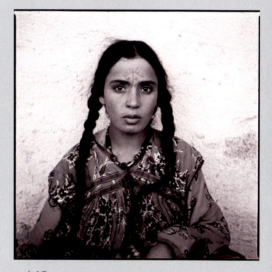

4.17

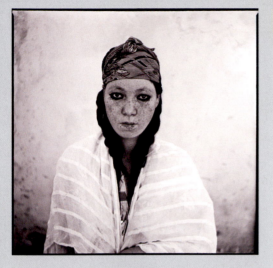

4.18

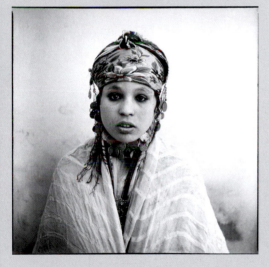

4.19

Synopsis

This case study has used some of the terminology of semiotics and shown that what at first appears as a straightforward portrait can be revealed as a complex structure of signs and forms, layered with issues of identity, ideology and power.

- Semiotics means that images can be treated as texts composed of signs to be read and interpreted.
- The specific meanings of a photograph depend not only on form and composition, but also on the contexts in which the photograph was produced and in which it is viewed, and also knowledge and information brought to the image. In short, meanings are not fixed.
- The gaze of the viewer, the camera and the person in the photograph constitute a complex set of relationships and meanings.
- The camera and photography can be instruments of control and ideology.

4.16–4.19

Title: *Femmes Algériennes,* 1960

Photographer: Marc Garanger

A selection from the 2,000 pictures of Algerian women that Garanger shot over ten days in 1960.

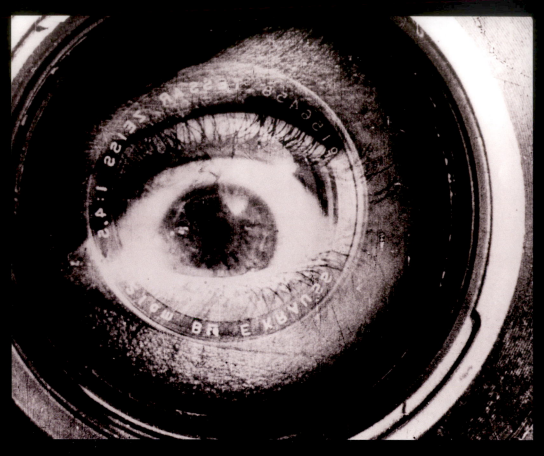

5.1

5.1

Title: Still from *Man with a Movie Camera*, directed by Dziga Vertov, 1929

Cinematographer:
Mikhail Kaufman

Vertov's ground breaking, silent documentary is a film about film. It is a modernist masterpiece exploring the nature of the photographic medium and its exploitation as a realist medium. The camera observes everyday urban life, catching subjects unaware and occasionally seeming to pry into private life.

Big Brother is watching you

Walker Evans said: *Stare. It is the way to educate your eye, and more. Stare, pry, listen, eavesdrop. Die knowing something. You are not here long.* Evans' advice to photographers is straightforward and seems appropriate in relation to a medium that is fundamentally about looking. A good photographer needs to be observant and sharp-eyed. But polite society has rules about looking: look too hard, too long, or too closely, and you can get into trouble.

As artist and critic Michael Rush has noted, *it is a short leap from looking (fixing one's gaze upon another), to voyeurism (taking delight in extended gazing), and to spying (surreptitiously studying the actions of another).*

Twenty-first century technology has given rise to unprecedented opportunities for both Big Brother to spy on us in public spaces, from CCTV cameras on the streets and satellites in the sky, and for the discreet and voyeuristic invasions of private space. Eyes, mechanical and human, are everywhere.

This chapter explores the proprieties and limits, the dangers, threats and thrills of looking, watching and being watched.

The development of photography in the nineteenth century was just one thread in the story of the Industrial Revolution, which saw dramatic changes in the organization of social life in Western Europe and America.

In brief, the application of steam power, in particular, gave rise to industrial production, a capitalist economy and urban concentrations of population.

The economic efficiencies of mass production meant that factory owners demanded a new level of discipline and control over the organization of labour; the growth of towns and cities also gave rise to issues of social control, as well as the emergence of new mass culture.

The mechanical process of photography, allied to new developments in printing technology, was perfectly suited to address these demands for discipline and entertainment. Indeed, as John Tagg shows in *The Burden of Representation* (1993), on the one hand, photographs were used by police forces, as early as the 1840s, to record the appearance of prisoners. On the other hand, entrepreneurs were not slow to recognize the pornographic possibilities of photography. *So outraged were the public representatives of the class that consumed these images so avidly in private that, by 1850, a law had been passed in France prosecuting the sale of obscene photographs in public places.*

The following sections will, in turn, explore photography as an instrument of control and surveillance, and of voyeuristic looking. The discussion will draw, in particular, on John Tagg's reading of Foucault's ideas about the relationship of power, knowledge, discipline and control.

Michel Foucault (1926–1984)

Foucault was a French philosopher, whose ideas about how power, knowledge and 'discourses' (systems of language, thought, institutional practices, etc) determine social behaviour and belief, have been hugely influential. Foucault's specific studies of the histories of knowledge, sexuality and madness have had application in a wide variety of fields of practice and study. John Tagg, in *The Burden of Representation* (1993) draws on Foucault to examine the 'disciplinary' use of photographic evidence by police, hospitals and other institutions.

5.2

Title: Example of photographic identification system used to identify criminals, 1880s

Photographer: Alphonse Bertillon

By standardizing the system for police photographic records, and accompanying images with detailed measurements, Bertillon made the process of identifying criminals much more efficient. The mug shot remains a key element in identification systems to this day.

5.2

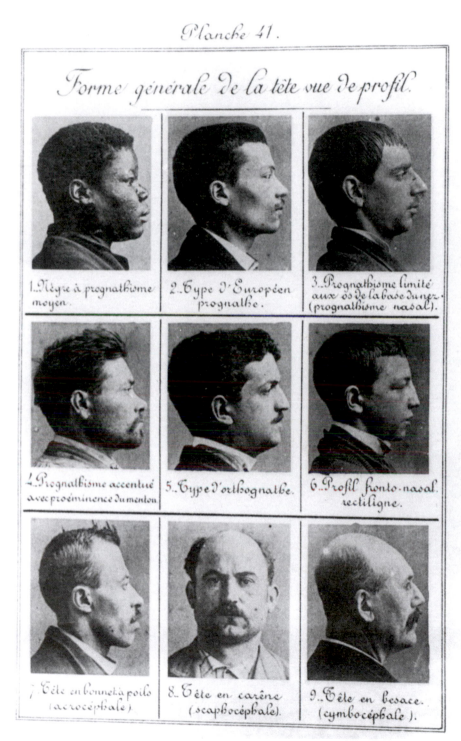

Planche 41.

Forme générale de la tête vue de profil.

1. Nègre à prognathisme moyen.

2. Type d'Européen prognathe.

3. Prognathisme limité aux os de la base du nez (prognathisme nasal).

4. Prognathisme accentué avec proéminence du menton.

5. Type d'orthognathe.

6. Profil fronto-nasal rectiligne.

7. Tête en bonnet à poils (acrocéphale).

8. Tête en carène (scaphocéphale).

9. Tête en besace (cymbocéphale).

5.3

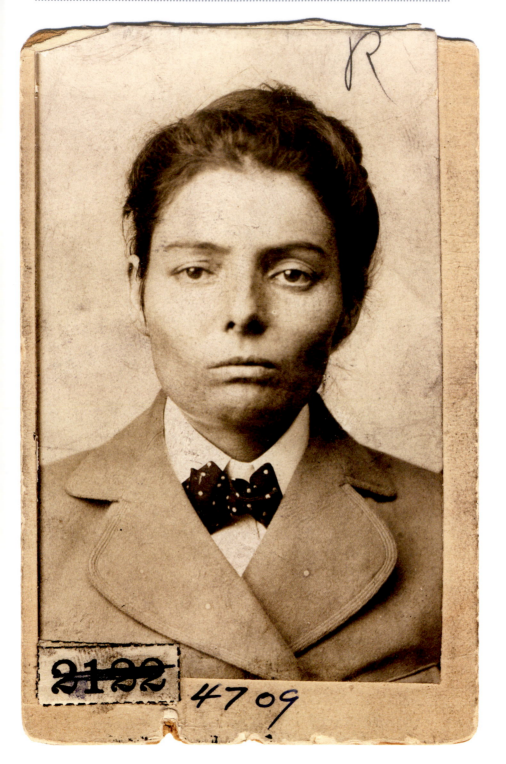

Mug shots

Today, it is impossible for a citizen in the developed world to get very far without some form of identity document featuring their photograph, such as a passport or driver's licence. Though the requirement to carry and show such documents has, at times, been met with resistance and associated with authoritarian governments, the practice has largely been passively accepted.

What exactly is the status of the identity picture, or 'mug shot'? Few would regard such a functional representation as a portrait in the terms discussed in Chapter 4. Indeed, the idea of 'identity' here is more limited and precise than discussed in that chapter: for bureaucratic purposes identity is a matter of dimensions (height), colour (skin, hair, eyes), age and origin (date and place of birth), and location (address). Individuals are objectified: fundamentally, the appearance of the individual must match the appearance denoted in the photograph.

Even though the possession of such documents is now routine and familiar, and accepted as a necessity, the experience of undergoing such a defining process may still have connotations of the police mug shot and associations of guilt. The formal requirements of, for example, the passport photograph (full face, neutral expression, plain background) derive from the standardization of early prisoner records and the 'scientific' studies of human 'specimens', medical and anthropological.

Tagg notes that prior to the standardization of the conventions of such photography, portraits of British prisoners taken in Birmingham in the 1850s and 1860s featured simple poses, but were *each mounted in an ornamental frame, as if they were destined for the mantelpiece.*

Alphonse Bertillon (1853–1914) is credited with developing the standard mug shot, which emerged from his invention of anthropometrics: a system devised to measure the unique and identifying features of individuals.

5.3

Title: Laura Bullion of the Wild Bunch Gang, mug shot from the Pinkerton Detective Agency, 1893

Photographer: Unknown

This striking 'portrait' of the outlaw Laura Bullion is a mug shot attributed to the Pinkerton Detective Agency.

Measuring the body

As Tagg notes, Eadweard Muybridge's studies of human and animal movement stand as exemplary in respect of a systematized photographic study of the subject. The movements of men and women, engaged in athletic or domestic activities, were photographed against a grid background by 36 cameras in three sets of 12, thus giving simultaneous frontal and angled views. The fact that the men and women were naked or semi-naked gives the images both the appearance of objective scientific study and a voyeuristic frisson.

Clearly, the visual scrutiny of human subjects can give rise to valuable information and knowledge. Muybridge's models are anonymous human 'machines' and while his studies are of lasting interest and value, at least for artists and designers, they tell us little about the human condition or psychology. What might be learned from a comparative visual scrutiny of faces or body types? How might one read, measure and classify personality types or intelligence?

The 'sciences' of phrenology and physiognomy were popular nineteenth-century methods of reading character; the former reasoned that personality is directly determined by the brain and, therefore, readable in the shape of the skull; the latter worked on the assumption that personality and character are directly inscribed into an individual's facial features and expressions. Charles Darwin's (1809–1852) revolutionary theory of evolution and heredity, and the emergence of new fields of study such as anthropology, criminology, and psychology, added up to a rich brew of ideas and beliefs about human nature and behaviour.

The application of photography, to such approaches led to theories and assumptions with potentially dangerous consequences. For example, Francis Galton (1822–1911) devised 'psychometrics' – psychological measurement – which, he claimed, allowed the visual identification of human 'types'.

5.4

Title: *from* 'Animal Locomotion', 1887

Photographer: Eadweard Muybridge

Between 1884 and 1886, Muybridge worked at Pennsylvannia University to produce an exhaustive study of human and animal movement, resulting in over 100,000 images.

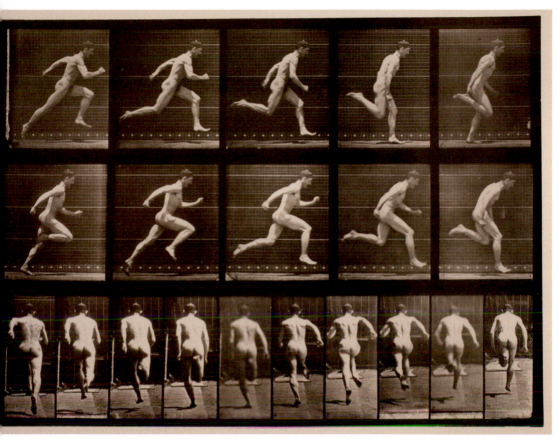

5.4

Galton superimposed standardized photographs of representatives of specific groups to form 'composite' portraits that, while erasing individual identity, would, he proposed, yield the visual representation of a criminal or other 'type'. The system could be applied to all social classes, cultural and ethnic groups to produce templates with which to classify human beings.

The dangers of this are clear. As artist and academic Michelle Henning puts it: *the popular sciences of phrenology and physiognomy, combined with new photographic techniques, produced a new and fundamentally racist vision of society.* Henning adds, tellingly, that it was just such a system which the Nazis adopted to segregate Aryan, Semitic and degenerate types.

Perhaps, to modern eyes, the clearest demonstration of a 'racist' gaze would be, for example, John Lamprey's 1860s anthropological studies of Malayan 'natives'. They were posed naked, in frontal and profile views, against a measuring grid background, so that a racial type is presented for study. The implicit assumption is that the body so presented is to be understood in its difference to the white Western viewer – who would never be subjected to such a humiliating and patronizing gaze.

Studies of madness

Other applications of the evidentiary capacity of photographs, ostensibly to further knowledge and understanding, include Dr Hugh Diamond's (1809–1886) studies of madness and psychological states in the female inmates of the Surrey County Asylum in the 1850s, and Guillaume Duchenne de Boulogne's, and later Jean-Martin Charcot's (1825–1893), portraits of patients in Pitié-Saltpêtrière Hospital in Paris. The former used electric shocks to stimulate his subjects' facial expressions, and the latter invited the public in each week to watch his patients 'perform' their symptoms!

While any claim for a scientific basis to such human classification cannot now be taken seriously, it is, nevertheless, easy to see that we still (perhaps unavoidably) subject people to an ideologically loaded gaze, and judge them and their representations according to stereotypes.

5.5

Title: 'The Old Man'

Source: *The Mechanism of Human Physiognomy*, 1862

Guillaume Duchenne de Boulogne, a pioneer in the study of neurology, set out to investigate how facial muscles produce expressions. Here the photograph records the effect of triggering muscular contractions with electric shocks.

5.5

George Orwell's novel, *Nineteen Eighty-Four* (1949), imagined a totalitarian society in which the population was kept in control and conformity by an authoritarian power whose face was 'Big Brother'. The slogan *'Big Brother is watching you'* was a constant reminder to all that they were under continual surveillance.

While the technology envisioned by Orwell has been outstripped by reality, concerns about freedom, privacy and state interference and control remain real political issues today. However, arguably, the model for modern surveillance is not the blunt instrument of Big Brother's direct gaze, but the more sophisticated concept of the Panopticon.

The all-seeing place

The Panopticon ('all-seeing place') was the invention of Jeremy Bentham (1748–1832). In 1791, he published an architectural plan for a prison building, designed to facilitate the constant observation of all inmates. In brief, this was achieved by a ring structure containing cells arranged as if radiating from the centre and open to the light at each end; a guard positioned in a central inspection tower could then observe all the inmates at any time. The psychological trick here is that because the guard is unseen by the inmates, they never know whether they are actually being watched, but know that they could be at any time – thus, the reasoning goes, they will behave as though they are being constantly watched. This is a secular application of the theological idea of the all-seeing eye of God: there is nowhere to hide.

Though Bentham's proposal was not taken up by the government of his day, the idea was recognized by philosopher Michel Foucault to have considerable metaphorical value in application to modern relations of power. The key principle is that we internalize the mechanism of observation. Rather than moderate our behaviour only when the police officer is watching, we carry a police officer in our head as a controlling conscience. In Foucault's words: *surveillance is permanent in its effects, even if it is discontinuous in its action.*

Today, we are generally very aware that CCTV may monitor our streets – even if we do not see the cameras – and that every keystroke on our computers is data that may be stored and used. The popular image of the Internet as a web emphasizes its extraordinary connectivity – but the fly caught in the web may be less concerned with its architecture than the threat to its survival!

5.6

Title: Drawing of a prison design, c. 1791

Source: *Management of the Poor* by Jeremy Bentham, (London, 1796)

This drawing shows the elevation, section and plan of Bentham's proposal for a prison structure designed to facilitate surveillance of inmates.

'A stupid despot may constrain his slaves with iron chains; but a true politician binds them even more strongly by the chain of their own ideas.'

J. Servan (eighteenth-century French soldier) quoted by M. Foucault, philosopher

5.6

Surveillance, as understood in relation to Big Brother and the Panopticon, speaks of the exercise of state power over citizens and interference in their lives. Similarly the snooping of a voyeur speaks of an invasion of individual privacy and the exercise of a psychological power.

We live in nervous times. In 2008, London's Metropolitan Police issued a poster which declared: 'Thousands of people take photos every day. What if one of them seems odd?'. On the grounds that 'terrorists use surveillance to plan attacks', it urged members of the public to report any photographer they thought to be operating suspiciously. Thus, the watchers are watched in a closed circuit of surveillance.

Anxieties about terrorist threats have also given rise to a belief that one might be able to visually identify the terrorist 'type' – despite ample evidence to the contrary; it is easy to see how 'vigilance' in this respect can slip into racist stereotyping. Signifiers of ethnic origins, coupled with those of cultural or religious affiliations, can be classified as 'other' and misread as threatening.

Photographing people can be an exercise in knowledge and power: to 'fix' them, to classify, label and objectify them.

However, it can also be to construct and assert identity. To manage one's own representation can be empowering: to know thyself.

It is perhaps surprising to consider, for example, that the very notion of individualism, which today is not only taken for granted as part of 'reality', but is accorded a fundamental value within the discourses of both democracy and consumerism, is a relatively recent invention, and one to which photography has significantly contributed. Foucault links the emergence of the individual with the rise of surveillance and information collection: *For a long time, ordinary individuality – the everyday individuality of everyone – remained below the threshold of description. To be looked at, observed, described in detail… was a privilege.* Formerly, only the great, the good and the powerful, were given the dignity of a recorded narrative of their lives.

Today, everyone has their defining 'biography' in the form of the family photo album, or presence on social media.

'We cannot blame the camera for what it has done to us; nevertheless, it has made certain human predilections much easier to satisfy… Human hunger to see the forbidden has not changed. The technologies to facilitate it have.'

Sandra S. Phillips, historian and curator

5.7

5.7

Title: Eye, 2012

Photographer: April Smith

Smith's extreme close-up of
an eye is both beautiful and
unsettling. It is rendered physically
strange, but retains an unnerving
psychological force: it looks at
us as much as we look at it.

As noted in Chapter 3, street photography has been claimed as the quintessential genre of the medium. It is, of course, a mode of (generally benign) surveillance. The photographer wanders the streets looking for social dramas and accidents, and interesting or beautiful faces: it is people watching, pure and simple.

Ethical questions with respect to privacy clearly arise – but generally the belief that, in a public space, the photographer is at liberty to photograph who and what they choose (within reason), is the view that prevails.

Between 1938 and 1941, Walker Evans rode the New York subway taking secret pictures of his fellow passengers. With his camera concealed beneath his coat, the lens peeking out between the buttons and a cable release threaded down his sleeve, he waited until the train was stationary before shooting 'blind' portraits of the passengers opposite. He was interested in capturing everyday reality with his subjects 'in naked repose', when 'the guard is down and the mask is off'.

Although there is nothing prurient about Evans' pictures, he described himself as 'an apologetic voyeur' and was sufficiently troubled by the invasion of his subjects' privacy to wait 25 years before publishing his pictures.

In 2000 – 2001, Philip-Lorca diCorcia set up a lighting rig on scaffolding in Times Square, New York, synchronized to a camera with a telephoto lens. When a member of the public entered his field of vision, he took a shot. The flash gives the resulting *'Heads'* a dramatic and filmic clarity.

One of diCorcia's subjects tried, unsuccessfully, to sue him for violation of his privacy; diCorcia has since commented, *I'm not sure I would like it to happen to me, but… there is really no expectation of privacy in a public place anymore in this world… it's about what you do with those images.*

5.8

Title: *from* 'Subway', 1980

Photographer: Bruce Davidson

The subway offers captive subjects for the photographer. Davidson's portraits on the New York subway in the 1980s are colourful, dramatic, intimate, claustrophobic and sometimes threatening. Here hands and bodies denote a physical closeness while faces are impassive masks.

5.9

Title: Woman reading, Paris, 2012

Photographer: Vicki Haines

Shot from across a Paris café, Haines makes a sympathetic study of a woman absorbed in reading, oblivious to the gaze of the camera.

5.8

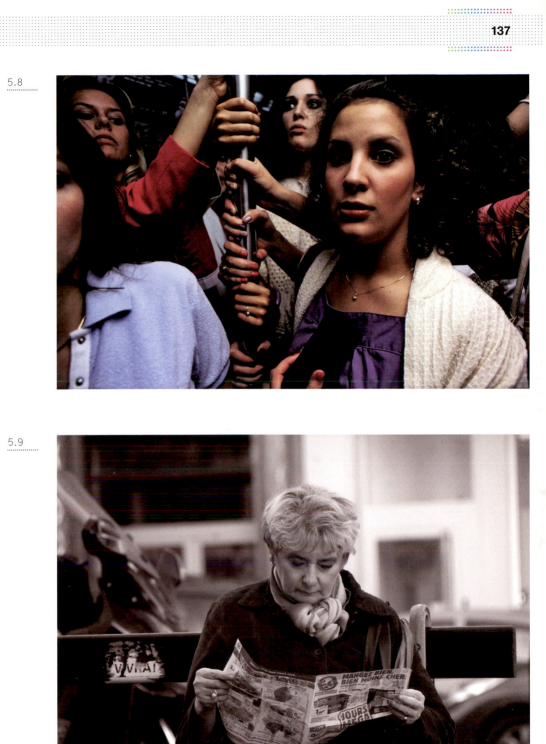

5.9

5.10

5.10

Title: *from* 'Anfisa's Family', c. 2008

Photographer: Irina Popova

Anfisa, the two-year-old daughter of Lilya and Pasha, plays with her sleeping mother's cigarettes. It is a picture guaranteed to trigger concern. Popova describes the parents as 'punks and drug users' and comments that, despite the chaos of their lives, 'they love each other and their little daughter and try to take care of her properly'.

Nosey parkers

Although voyeurism is generally associated with spying on sexual activity or scenes of intimacy, the term can also be applied to transgressions of conventional rules of privacy or propriety.

Sophie Calle (b. 1953), for example, liked to follow strangers – and secretly photograph them. Her work *Suite Vénitienne* (1979) documents her tailing a man from Paris to Venice.

The photographs of Enrique Metinides (b. 1934) show the terrible consequences of fatal accidents in grim, unflinching detail – as well as the crowds of onlookers drawn irresistibly to stare at the tragedy. As the critic Adrian Searle put it: *We see things we feel we shouldn't be looking at, but it is hard to drag our eyes away.*

Russian photographer, Irina Popova, after a chance encounter with a mother and her child, briefly went to live with her in the one room apartment she shared with her boyfriend. The living conditions were poor and when she published frank photographs of their chaotic, unconventional, but in Popova's eyes, happy lifestyle, they were read in different ways.

In writer Blake Morrison's account, when Popova showed them to a curator, what she saw as representations of love, he saw as 'degradation and despair'; when she published the images on the Internet, bloggers in their hundreds hurled abuse. *They were outraged that anyone should live as [they] did. Outraged that they should be allowed to raise a child in those conditions… There was talk of prosecution. A campaign began to remove (the child) and put her in an orphanage.*

Life on Google Street

The issues raised in this chapter are all concisely present in the contemporary Google Street View project. The benign human interest approach of street photography is combined with the faceless quasi-bureaucratic data collection of surveillance. On the one hand, this seems to be a simply useful and objective mapping exercise. On the other hand, the indiscriminate and random documentation of everyday life is at once banal, fascinating and potentially intrusive (the author is immortalized in the Google database, at home, putting out the rubbish for collection!).

Some very interesting and controversial projects have emerged on the back of Google Street View. Photographers including Michael Wolf, Jon Rafman and Doug Rickard have 'mined' the Google data for selected images, which they copy, crop, enlarge and exhibit – as art! While this practice precisely follows the logic of the medium, it has added to the apparently endless and unresolvable debate about the status of photography as a creative practice. When Wolf was given an 'honourable mention' in the 2011 World Press Photo Awards, it provoked objections that this was not proper 'photography' let alone photojournalism or art! As writer Geoff Dyer has noted, in some cases Rafman has even used the same images as Wolf – so whose pictures are they? And does the question of authorship matter?

As Geoff Dyer also noted, the Google camera cars generally go about their business unnoticed or unheeded, and mechanically produce millions of uneventful pictures. However, things still happen – there are accidents, there are fights, and on the occasions when the camera is spotted, people respond with gestures: the very stuff of street photography.

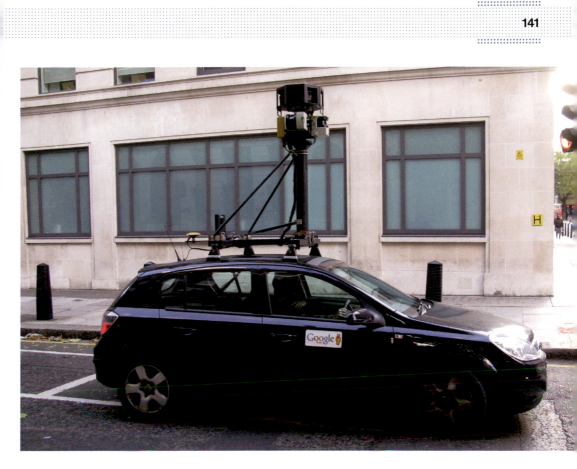

5.11

5.11

Title: Google street view car, London, UK, 2008

Photographer:
Harold Cunningham

Nine cameras mounted on a mast equip the cars to record a sequence of 360° panoramas of the street as they proceed. The resulting images, stitched together, constitute a comprehensive, mechanized representation of our world, and provide the opportunity to virtually travel the streets of world cities from our computer screens.

Case study
Shizuka Yokomizo

This chapter has considered aspects of the psychology and politics of looking and watching.

- What are the ethics of looking and photographing? Consider the point of view of both the photographer and the subject, who may not have given permission and may be unaware of being photographed.

- How far can you go? Is any behaviour in public space fair game for the photographer? Is private space that is visible from public space also fair game? Where does privacy begin and end?

- Respond to this observation by the critic A.D. Coleman: *The assumption that you waive your rights to control your own image and declare yourself to be free camera fodder by stepping out of your front door is an arrogance on the part of photographers.*

Voyeurism and surveillance both assume a one-way gaze, from the camera to the subject.However, while the desire to look may well be universal, the desire to be seen is not uncommon. For many, the gaze of the camera is welcome. In some respects, the marriage of voyeur and exhibitionist is a perfect match.

An interesting twist on the relationship between the watcher and the watched, between the photographer and her subject, is Shizuka Yokomizo's project *Strangers*. Yokimozo wrote anonymous letters ('Dear Stranger') to the occupants of selected addresses, inviting them to stand at their window at a specific time at night, with the lights on, and be photographed.

The pictures seem to be the essence of voyeurism: we gaze through a window into the private space of strangers. The window becomes a metaphor for the gaze of the camera. Yet the subjects have chosen to participate in this encounter with the photographer and look out at her. Yokomizo has written that: *It was important for me that the subject, a stranger, made eye contact with me while I was photographing. I realized that I needed these people to look back and recognise me equally as a stranger.*

The pictures are both intimate and consensual: the subjects participate willingly in the transaction. The pictures may look like voyeurism or surveillance, but are the result of a degree of trust and openness that is normally absent from those practices.

5.12

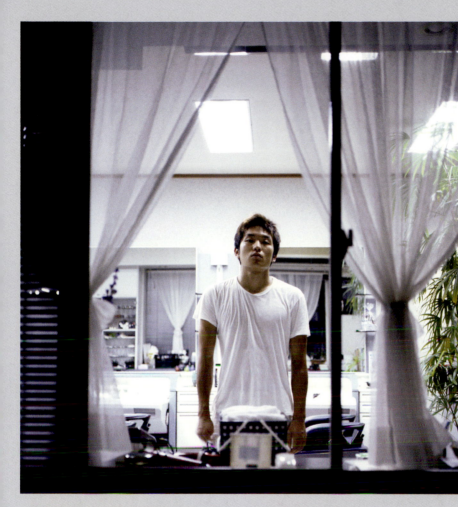

Synopsis

This case study has raised questions about the ethics and responsibilities of photographing people.

- The relationship between the photographer and the subject raises issues of power and trust.

- The photographer must consider his or her responsibility towards the individual's rights to privacy even within public spaces.

5.12

Title: *from 'Stranger', 1999*

Photographer: Shizuka Yokomizo

At a pre-arranged time, a man looks out from the window of his apartment, to where Yokomizo sets up her camera, takes a photograph and leaves. Photographer and subject see each other, and collaborate, for a brief moment.

6.1

Title: Self-Portrait ('Lola'), 2004

Photographer: Sarah Roesink

This beautiful image was a 'test
shot' Roesink took with a pinhole
camera made out of a shoe box.
'When I developed the paper, I
saw that the image had come
out in these amazing colours, as
if I'd taken it in a hot country. I
was so blurry that I looked like a
ghost, or someone in a dream'.

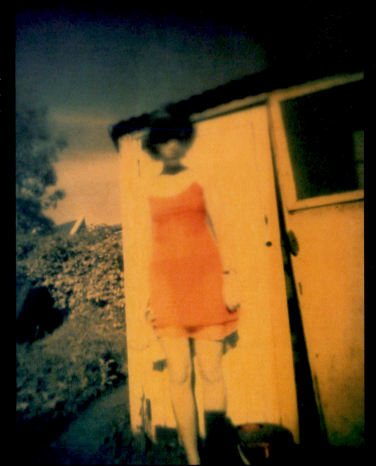

6.1

Aesthetics

The core question in aesthetics is: but is it art? It is a question that has dogged photography from the outset, and which remains alive today. The key problem in addressing this is to agree on what 'art' is – no easy task.

How do you tell a photograph that is art from one that isn't?

What is clear is that most photography in the world, and most that we encounter on a daily basis, has nothing to do with art. Which is not the same as saying that most photography is not concerned with aesthetic questions of taste and judgement. Confusingly, one can discuss the 'art' of photography – meaning the skills of the practice – without this signifying whether the image in question is or isn't 'art' itself.

For many, the issue of whether a photograph is or isn't art is seen as an irrelevance – and perhaps a pedantic and pretentious one, at that; at best, all that matters is deciding whether a photograph is any good. However, agreeing on the criteria for deciding even that is no easy task.

Nevertheless, to claim something as art is to make a claim about its value, meaning and purpose – to see it in a particular way. From the start, photographers have been concerned in making work that commands and repays attention over and above pure informational content; to make work that is seen to be valuable in itself.

This chapter will consider the debates about photography as art and present a brief history of the idea of photography as art.

In 1855 and 1857, two cartoons, drawn by the photographer Nadar (1820–1910), appeared in French popular journals. The first showed a camera standing on its tripod and knocking at a firmly closed door, with the caption: *Photography asking for just a little place in the exhibition of fine arts.* The second showed a camera being kicked out of the door by a painter's palette: *The ingratitude of painting, refusing the smallest place in its exhibition to photography, to whom it owes so much.*

The relationship of photography to art has been, from the first, uneasy. Painters, such as Gustave Courbet (1819–1877) and Edgar Degas (1834–1917), were quick to employ the usefulness of photographs as a visual reference, but slow to acknowledge their independent status as works of art.

Clearly, the mechanical nature of photography and its reproducibility were provocative to an age-old tradition of picture making, which was premised on manual skills and the uniqueness of the art object.

In their turn, those early photographers who were determined to establish the medium as art (Pictorialists), were slow to escape a visual language inherited from the painting of an earlier age. Arguably, it was not until the 1920s and 1930s that modernist photographers (for example, Aleksandr Rodchenko and Walker Evans) developed a distinctive aesthetic language that emerged from the nature of the medium itself.

6.2

6.2

Title: Bethlehem Graveyard and Steelmill, Pennsylvania, 1935

Photographer: Walker Evans

Evans' characteristic style, which flattens perspective, produces a brilliantly compressed image of an industrial town, here. Mary Warner Marien states that the image: *symbolically guides the viewer from background to foreground through a fatal progression of work, home life, and death.*

The end of painting

The prediction that painting would die with the advent of photography was clearly wrong: painting continues to thrive. However, the notion of what art is, has, in some respects, changed since photography was invented. Many of the icons of modern art would be incomprehensible as art to a nineteenth-century viewer – although, admittedly, they remain so to some twenty-first-century viewers! It could be argued, for example, that the efficiency of photography in producing accurate, realistic representations of the world liberated painters to explore other possibilities, for example, with respect to imagination, expression, colour, abstraction, and so forth.

Today, photography is at home in the major galleries and museums of art, and, as David Campany has noted in *Art and Photography* (2003), 'art has become increasingly photographic'. This is to say that photography is simply one medium amongst many, which is increasingly employed by artists in diverse ways. The contemporary definition of art is not to be found in the essence of any single medium, but in the qualities of the resulting work that exploits it. Nevertheless, what actually qualifies as 'art photography' remains contentious.

6.3

6.3

Title: Icy Prospects #21, 2006

Photographer: Jorma Puranen

Puranen's beautiful, arctic landscape photographs have the look of paintings. In fact, they are long-exposure photographs taken of the landscape reflected in the black, glossy surface of a painted wooden board.

The British philosopher Roger Scruton has argued very forcefully that photography *cannot* be art. The relationship of a photograph to what it depicts is, he argues, causal – what appears in the picture is caused by the appearance of the world in front of the camera; the camera has no imagination – it can only show what is there and what exists. Furthermore, he argues, our only interest in a photograph is interest in the thing photographed. Just as we look through a window to the scene beyond, we look 'through' the photograph; we are not interested in the photograph as an object in its own right, as would be the case with a painting.

A photograph thus fails, in Scruton's court, to fulfil the minimum requirements of a work of art – that it should express something about the world (not simply show it), and that it should be an object in its own terms.

Of course, as the history of image manipulation demonstrates, a photographic image need not simply show reality, but Scruton's answer here is that in fiddling with the 'truth' of the image the photographer denies the essence of photography and has become in effect a painter.

Scruton's view is deeply unfashionable and unpopular. Nevertheless, it seems persuasive in some respects and it is worthwhile reflecting on his arguments and identifying exactly what we understand photography to be, what is involved in making a photograph, and what we expect of something labelled as 'art'.

6.4

Title: Wine glass, 2009

Photographer: Richard Salkeld

Although the image here shows what was in front of the camera, it could be argued that any interest lies not in the wine glass itself, but in the camera's registering of the visual effects. The camera's view of the world is not, after all, identical to natural vision.

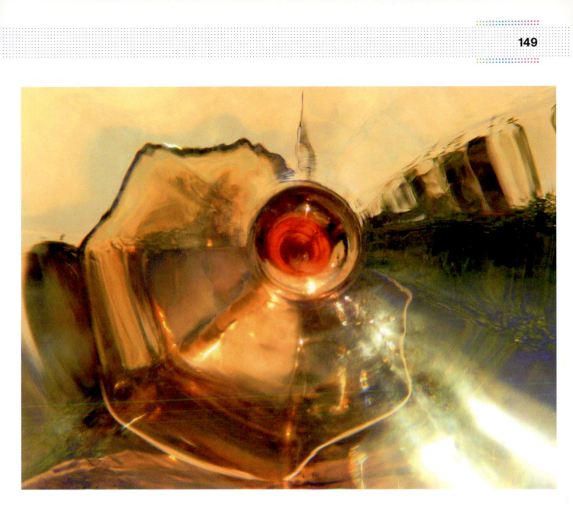

6.4

'A photograph is never interesting
for its own sake, as art must be…'

Roger Scruton, philosopher

The problem of photography

The perceived problem of photography (as art) is, basically, that it is easy and it is mechanical.

Anyone can take a reasonably competent photograph. Is everyone, therefore, an artist? Should a work of art demonstrate particular, hard won, skills?

As Scruton points out, a camera simply and mechanically records what is in front of it. Traditional (handmade) works of art have come about through a process of perception, interpretation and expression. How can a photograph be said to 'express' the thoughts and feelings of the photographer?

One answer to the first charge might be that, in fact, photography does require a high degree of skill and knowledge; that decisions about exposure, lighting and framing are complex and specialist skills. It is certainly possible to admire and appreciate skillful picture making, but it would surely be absurd simply to equate art with technical skill?

While one may agree with Scruton that photography is both causal and mechanical, it does not follow (as argued in Chapter 3) that a photograph is a direct transcription of reality. A camera sees differently to the human eye and a photograph is a picture, which is determined not just by what is in front of the camera, but also by the particularities of the apparatus and the decisions made by the photographer.

The question of whether or not a photograph can be expressive, and whether expression is essential to a work of art is more complex. Expression is certainly one valid purpose of works of art, but the history of art would suggest it is not a *necessary* one. Furthermore, it has been the argument of this book that treating a photograph as a signifying text means that, to some degree, the feelings and thoughts of the photographer are not directly accessible. To some extent, they are irrelevant – the 'meaning' is made by the viewer in the process of looking at the image.

Nevertheless, every photograph is, literally, a point of view; every photograph implicitly says, 'look at this', and 'look at in this way'.

6.5

Title: Kym, Polish Palace, *from* 'Sleeping by the Mississippi', 1999

Photographer: Alec Soth

Although Kym is very clearly the subject of the photograph, the picture is dominated by the overwhelming colour of the bar's décor. Soth has simply documented the scene before him, but in orchestrating the colour tones he has made a picture suffused with sadness.

6.5

'I photograph things to see what they look like photographed.'

Garry Winogrand, photographer

Debates about whether a photograph (or, indeed, any object) is a work of art, turn upon a working definition of art.

There will never be unanimity in this matter – yet, as will be shown below, there is, apparently, a broad consensus about which photographs constitute the canon – that is, the 'official' list of great photography. The recognition that such lists are the products of particular individuals and institutions and reflect particular cultures and fashions, points away from a universal or essentialist idea of art and towards one that is discursive, which is determined by histories, practices and debates.

It is clear from the contemporary art world that anything *can* be a work of art – a urinal (Marcel Duchamp, *Fountain*, 1917), a facsimile of a 'Brillo Box', (Andy Warhol, 1964), an unmade bed (Tracey Emin, *My Bed*, 1999), a photograph of another photograph (Richard Prince, *Cowboy*, 1989); but it does not follow that everything is a work of art. What these examples have in common is that the institutions and discourses that constitute the art world have validated them.

The problem with this line of reasoning is that it might suggest that a self-serving and elitist clique has defined art in its own terms and is sharing an expensive joke at the expense of the general public. This would be an understandable, but nevertheless very cynical, view!

No matter how hard you look at a picture or an object you cannot point to its 'artness' (the quality of being art). You may not like the examples listed above, but you cannot deny that they exist to be considered and experienced in the context of art – and that they were admitted to that world, not on a whim, but on the basis of a history of practices and beliefs.

6.6

Title: After Sherrie Levine, 2012

Photographer: Richard Salkeld

In the 1980s, Sherrie Levine exhibited as art her openly re-photographed images by Walker Evans, Edward Weston and others. These provocative acts have been seen as a critique of the notion of originality in modernism. Here, the photograph of a photograph by Levine of a photograph by Rodchenko, is clearly a picture of a work of art, but is not one itself!

6.7

The ready-made and the photograph

The concept of the 'ready-made' is now 100 years old. The term was coined by the artist Marcel Duchamp to describe an ordinary or found object which, without any alteration, is declared to be a work of art. Duchamp created the first such work, *Bicycle Wheel*, in 1913, and in 1917 the more famous and scandalous *Fountain* – a shop-bought urinal.

Duchamp simply *took an article of life, placed it so that its useful significance disappeared under the new title and point of view – created a new thought for that object.* In effect, this is a way of 'making strange' as well as drawing attention to the production of meaning through a semiotic process of reading images and objects (see Chapter 2).

Whether or not one is persuaded that these objects become art on the artist's say so, depends upon the ideas and beliefs about art and perception that inform understanding. In the century since Duchamp's provocative gesture, the debates arising from it have become embedded in the discourse of art – in the practices, literature and institutions – and have effectively given licence to others to perform similar transformations. However, it does not follow that *anyone* can declare *anything* to be a work of art, or that the ideas must be accepted. What does follow is that any engagement with such a work forces reflection upon the meaning and value of art, and the criteria for conferring that status upon an object or image.

Arguably, every (unmanipulated) photograph is a form of ready-made – it is 'taken' from the world around us; any photograph has the potential to provoke a new thought, a new way of seeing, and, indeed, to be a work of art. Whether it is seen to be a work of art, or not, depends upon the context within which it is presented, and the conversations that take place in response to it.

How you read a photograph depends upon the specific context of viewing, as well as the cultural context of the time. The following sections sketch out the evolution of ideas about photography as art.

6.7

Title: Mask XXIX, 2006, collage

Artist: John Stezaker

Stezaker has used ready-made photographic material to create this image. A found postcard of the interior of a cavern has been inverted and overlaid onto a found publicity portrait of an unknown actress. Stezaker brilliantly aligns contours in the card and face to create the illusion of a grotesque skull revealed beneath the skin.

The official birthdate of photography is considered to be 1839 – when the daguerreotype process was announced to the world. However, as noted in Chapter 1, the first photograph is reckoned to be by Niépce in about 1826.

For the historian of photography, it is very helpful to have such a precise (and relatively recent) starting point; however, the medium has proved to be so prolific that it quickly becomes difficult to decide what to include and what to leave out.

Given the overwhelming number of images in the world, it can come as a surprise to find that the published histories generally represent the story, not only with a relatively small number of images (two of the most substantial histories, by Naomi Rosenblum and Mary Warner Marien, each contain less than 1000 images), but to a significant degree with the same or similar images. In short, there exists a canon of images – that is, a generally agreed list of photographs which are taken to be the most important achievements in the medium. However, it is worth reflecting on how such a selection came about: who made these evaluations, on what criteria, and importantly, what was left out?

The History of Photography (first published in 1949) written by Beaumont Newhall (1908–93) was the first serious history of the medium, and it effectively mapped out what became the official account of the story of photography.

Newhall worked for the Museum of Modern Art, New York, so it is perhaps no surprise that his approach emphasised photographs considered as art, but also the specific acquisitions of that museum. As such, it established a modernist history, that is, one in which attention is given to images associated with so-called high culture – thus most photography in the world went unconsidered.

6.8

Title: Self-Portrait, 1902

Photographer: Edward Steichen

A portrait of the photographer as a young artist: Steichen poses with palette and brush – thus signifying 'artist'. The image even looks like a painting: the effect is achieved by a layered printing process using gum bichromate.

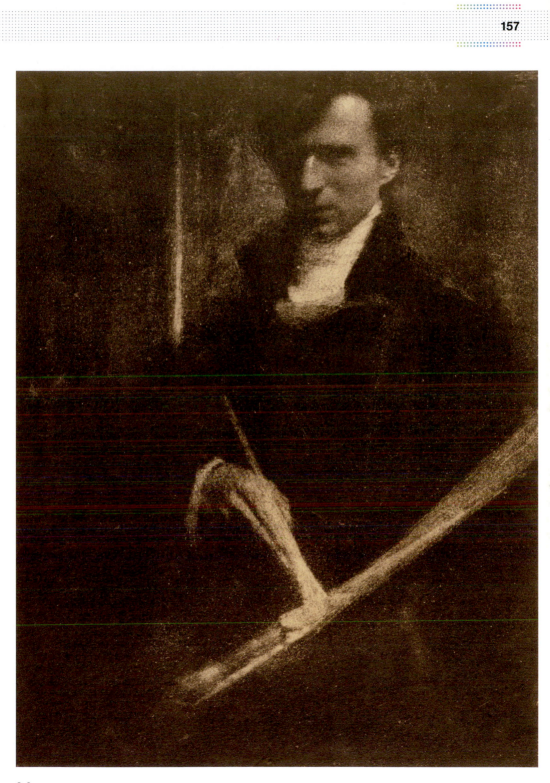

6.8

From pictorialism to 'straight photography'

When photography was invented, it was not immediately clear exactly what this image-making technology would be used for. The first photographically illustrated book to be published, Fox Talbot's *The Pencil of Nature* (1844–1846) tested out some of the possibilities by including street scenes, architectural studies, still lifes, copies of prints, and composed scenes, thus signalling both the reproductive and creative potentials of the medium.

Given that up to this point all images in the world were essentially handmade – even if printed they derived from a hand-drawn original – it is not surprising that early practitioners looked to the language of visual art to guide them. Indeed, writing about his composition, *The Open Door*, Fox Talbot observed that *We have sufficient authority in the Dutch school of art, for taking as subjects of representation scenes of daily and familiar occurrence. A painter's eye will often be arrested where ordinary people see nothing remarkable.*

Early enthusiasts for photography, with artistic ambitions, took care with their choice of subjects and composition to create naturalistic or poetic 'pictures' of subtle tones and soft focus – even using materials that allowed the addition of coloured pigment and the manipulation of the surface with a brush to create a painterly effect. 'Pictorialism', as this approach has come to be known, was photography claiming the status of art by imitating painting and disguising the mechanical aspect of the medium. It flourished from about 1860 to 1920 and included amongst associated practitioners Julia Margaret Cameron, Robert Demachy, Clarence H. White and Edward Steichen.

The irony of the pictorialist approach was that it employed a new, modern technology to make pictures that looked like old-fashioned art. In the same period, painters, from Manet to Monet and Cézanne to Picasso, were dispensing with naturalism and making radical experiments, which led to a new visual language of abstraction.

6.9

Title: Speed, 1904

Photographer: Robert Demachy

Demachy was a master of the gum-bichromate method, which allowed the manipulation of the print to give an 'artistic', impressionistic effect. Typically, his subjects were nudes, landscapes and portraits; this is a rare image of 'modernity' in which the method is used to signify the sensation of speed.

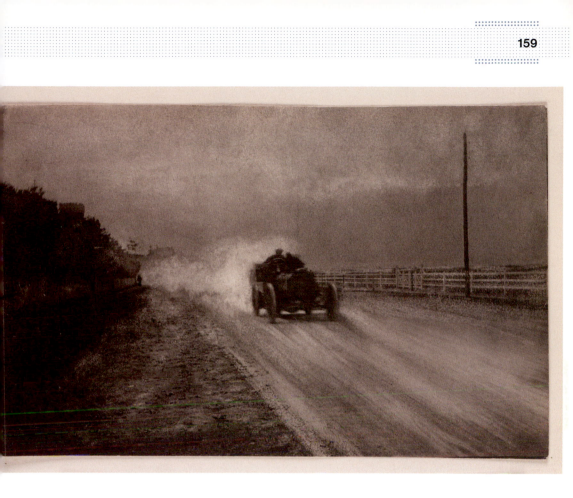

6.9

Photography and modernism

Modernism can be understood as the cultural response to (but not necessarily representation of) the technological and social effects of modernity – broadly, the consequences of industrialization. In the late nineteenth and early twentieth centuries, in particular, a raft of inventions (photography, cinema, radio, cars, aeroplanes) transformed social structures, organization, communications and behaviour.

Writers, architects and artists responded to the excitement, dynamism and danger of the modern urban, technological world with new forms and new materials. One of the mantras of modernism was 'truth to materials'. This was most obvious in architecture where the form and appearance of modernist buildings were determined by the materials, (concrete, steel and glass), from which they were constructed – pure forms with no decoration. Painters, perhaps surrendering the job of making realistic, illusionistic representations of the world to photography, experimented with the medium itself and drew attention to paintings as objects, as constructions of colour and form.

Photography (with cinema) was, perhaps, the exemplary medium of modernity. The advent of faster films and smaller cameras (notably the Leica, in 1925) meant that photography was perfectly suited to capturing and representing the modern world; not through images that looked like paintings, but by being true to a photographic way of seeing, catching the immediacy of a moment, and by disseminating images through the mass medium of the photo magazine (for example, *Life* from 1936 and *Picture Post* from 1938).

The new vision

In the politically volatile conditions of Germany and Russia in the 1920s and 1930s, photographers such as László Moholy-Nagy and Aleksandr Rodchenko forged what came to be known as 'the New Vision' – part photojournalism, documentary photography and avant-garde art all rolled into one.

In America, Alfred Stieglitz, through his own photography and through his gallery and magazine (*Camera Work*, 1903–1917), tirelessly promoted European avant-garde art and straight photography, notably the work of Paul Strand. Other photographers, such as Edward Weston and Ansel Adams, while preferring traditional subjects such as the nude, the still life and landscape to the urban world of modernity, nevertheless took a purist approach to their work pursuing technical perfection and an aesthetically transcendent vision. Weston's long exposures of shells, for example, imbue the subjects with intense luminosity and tonal richness.

6.10

Title: The Tetons and the Snake River, 1942

Photographer: Ansel Adams

Adams personified purist, 'straight' photography. Using a large format camera, small aperture and long exposures precisely calculated in relation to the light in the landscape, he achieved images of astonishing depth of field and detail, which were perceived as 'true' to the characteristics of the medium.

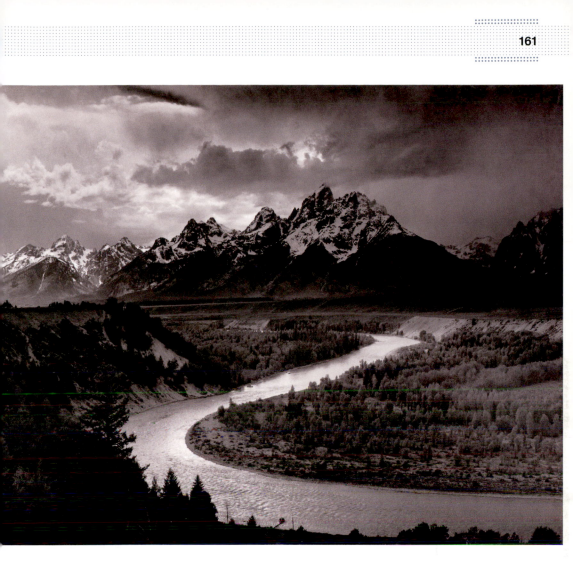

6.10

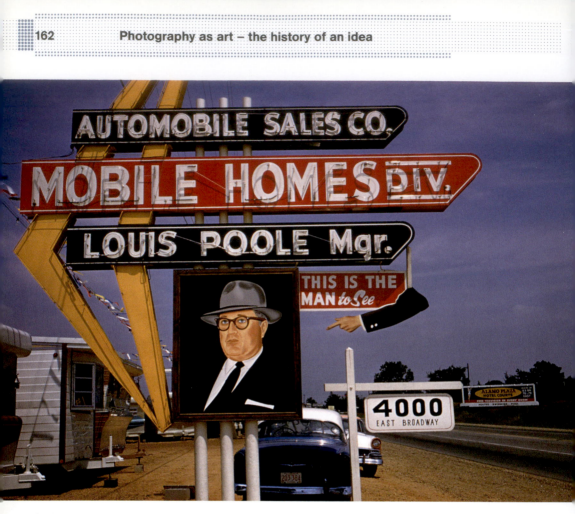

6.11

6.11

Title: Outside Memphis, Tennessee, 1960

Photographer: Inge Morath

Colour photography was commonplace in the 1960s in advertising and popular culture, but rare in art photography, until it was 'discovered' in 1976 when MoMA exhibited work by William Eggleston. Morath's picture of a roadside sign echoes Walker Evans' fascination with American vernacular art and anticipates Eggleston's eye for the colour and form in the everyday.

MoMA: writing the canon

The Museum of Modern Art, New York was established in 1929 and from the start the director, Alfred Barr (1920–1981), was determined that the institution should be concerned with not just painting and sculpture, but also architecture, film, design and photography.

In 1937, Beaumont Newhall organized an historical survey exhibition, *Photography 1839–1937*, the catalogue for which effectively became the first significant history of the medium, and laid the foundations for his influential *History of Photography* published in 1949. Newhall also organized the museum's first exhibition devoted to an individual photographer, *Walker Evans: American Photographs* (1938) and became the first curator of photography at the museum in 1940.

Edward Steichen served as Director of the Department of Photography from 1947 until 1962 when he was succeeded by John Szarkowski who held the post until 1991. A string of exhibitions and books (produced by MoMA) including, for example, *The Family of Man* (1955), *The Photographer's Eye* (1966), *New Documents* (1967), *Mirrors and Windows: American Photography Since 1960* (1978) helped to write the official history of the medium, identifying the modern masters.

In *The Photographer's Eye*, Szarkowski spelled out what he identified as the essence of photography under five headings: *The Thing Itself* (meaning the photographer has to deal with the real world in front of him); *The Detail* (the photographer records fragments of the real world, which he may imbue with special significance); *The Frame* (the photographer is bound to select what appears within, and what is excluded by, the frame of the picture); *Time* (a photograph records the specific moment of its making, and its appearance is determined by the length of that time); *Vantage Point* (a photograph always shows a particular point of view).

This characterization of the nature of photography emphasizes the aesthetics of the photograph and its 'autonomy' or self-sufficiency as a picture. This conforms to the modernist ethos of art, which accords special status to the 'masterpiece', but tends to detach the work from its context of production. It is this approach that shaped the now familiar story of 'great' photography: the canon.

After modernism

The paradox of the modernist ethos was that while the photograph was necessarily a trace of reality – in Szarkowski's words, concerned with 'the thing itself' – the emphasis on aesthetics and form in the picture meant that it was effectively detached from that reality. Walter Benjamin argued that such images *can endow any soup can with cosmic significance but cannot grasp a single one of the human connexions in which it exists.* Thus, a photograph of a detail of a modern factory may show us a visually arresting composition of line and form, but it can tell us nothing about the social and economic structures that the very existence of the factory represents.

From the 1960s and through the latter part of the twentieth century, the assumptions of modernism in relation to all cultural production came under increasing scrutiny and challenge from practitioners, critics and theorists.

In photography, as in other fields, the rise of postmodernism has seen a shift in emphasis from a preoccupation with pure aesthetics – the visual look and design of the image – to a concentration on the contexts both of the production of the image (when, who, why) and of the viewing of the image (where, by whom, with what information). In short, the photograph came to be treated as a 'signifying text' (see Chapter 2) in which as much attention was paid to what was outside the frame of the image as was within it.

While this shift has certainly not meant that photographers no longer make beautiful pictures, it does mean that a purist approach is no longer privileged in the way that it used to be; it has opened up a whole range of photographic practices, from amateur to commercial, and functional to artistic, for serious critical consideration.

6.12

Title: COR-TEN, 2009

Photographer: Richard Salkeld

The streaks of colour and apparently gestural marks in this photograph borrow the 'look' of a modernist abstract painting. However, a different context is implied by the denoted texture of the surface. It is a close-up of rusting steel; but the colours are not true to natural vision and are a product of processing. Ironically, the steel surface belongs to a modernist sculpture by Richard Serra.

6.12

Conceptual art and photography – where's the skill in that?

While it is clear that some institutions (notably MoMA) accorded high aesthetic status to a certain sort of photography (by, for example, Walker Evans, Robert Frank, William Eggleston), there generally remained a degree of segregation, and even a hierarchical relationship, between photographers and artists.

However, the emergence of conceptual art in the late 1960s and early 1970s saw artists embracing photography in a way that might have suggested that the medium was, at last, integrated into fine art practice and its institutions, but which actually, perhaps, drove the wedge between them even more firmly.

While professional photographers were generally marginalized by the fine art world, 'artists' who 'used photography' were welcomed in. Understandably, this appeared discriminatory from the point of view of photographers. To add insult to injury, some conceptual artists who used photography appeared to be indifferent to the technical niceties of the medium and used it in a deliberately casual and even amateurish way. For example, Robert Smithson's *Monuments of Passaic* (1967) comprised photographs of mundane sites in Passaic, New Jersey taken with a cheap Instamatic camera; Edward Ruscha's *Twentysix Gasoline Stations* (1963) was a cheaply produced book of technically unremarkable photographs of 26 gasoline stations. Both of these bona fide works of art exist only through the medium of photography, but neither would impress as a demonstration of 'fine' photography.

Conceptual art was not only provocative to photographers, but also to traditional fine artists, whether painters or sculptors. Conceptual art was, in part, a response to the idea of the ready-made and proposed a rethinking of the nature and purpose of art: it was a challenge to the idea of the artwork as simply a beautiful and collectable commodity to be passively admired; the conceptual artwork required the viewer to engage in active 'reading'.

6.13–6.15

Title: *from Twentysix Gasoline Stations*, 1963

Photographer: Edward Ruscha

Ruscha's little book delivers what it says on the cover: 26 black-and-white photographs of gas stations. Each picture is captioned with a location. That is all. The photographs seem indifferently composed and executed. Not quite documentary, not obviously art. Yet the book's cool, minimalist aesthetic continues to intrigue and mysteriously assert its status as art object.

6.13

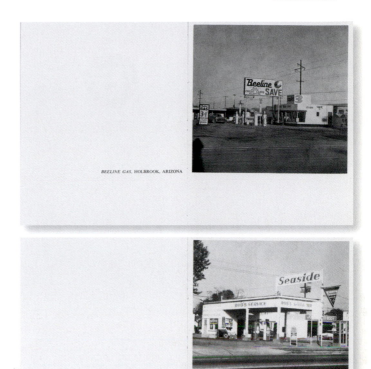

BEELINE GAS, HOLBROOK, ARIZONA

6.14

BOB'S SERVICE, LOS ANGELES, CALIFORNIA

6.15

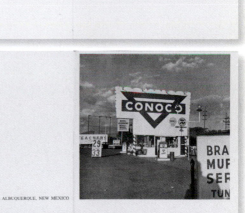

CONOCO, ALBUQUERQUE, NEW MEXICO

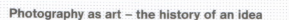

6.16

'For every photographer who clamours to make it as an artist, there is an artist running a grave risk of turning into a photographer.'

Nancy Foote, writer and critic

The Tate Gallery, conceptual art and photography

The mutual suspicion between fine art and photography camps was fuelled in the UK by the position taken by the Tate Gallery in 1982 in relation to conceptual art. In an interview, the then director, Alan Bowness, explained that the Tate (the British national collection of modern art) would not collect the work of a photographer: *Someone like Bill Brandt, for example, we would not collect because he is exclusively a photographer*, but it would collect the work of an artist who used photography: *The photographic works in the Tate collection all have this same characteristic, they are works by artists*. Thus, an artist such as Richard Long for whom photography was an element in the documentation and presentation of his sculpture was included in the collection, but so too were Bernd and Hilla Becher who worked exclusively in photography!

The contradictions and confusion evident in such contortions are not simply evidence of snobbery (though the art world is certainly not immune from that!), but a demonstration of the operation of the prevailing discourse; the fact that such a position would be unsupportable today is a mark of the cultural changes that have since occurred and which might be characterized as the slide from modernism to postmodernism.

The Tate's position in relation to photography is now very different – but it remains almost shocking to note that it did not hold its first major photography exhibition until 2003 (*Cruel + Tender: The Real in the Twentieth-Century Photograph*) and only appointed its first photography curator in 2009 – some 50 years behind MoMA! Perhaps it is not so surprising, in retrospect, that MoMA's John Szarkowski felt able to write in 1973, that, *it might be said that photographic tradition died in England sometime around 1905… and showed no signs of seeking a photographic present.*

The institution is now making up for lost time and photography is fully integrated into the exhibition programme.

6.16

Title: Tate Modern, London, 2008

Photographer: Photofusion

In 2008, Tate Modern hosted a major photography exhibition: *Street and Studio: An Urban History of Photography*. At the same time, they commissioned six artists to adorn the building with 'street art'. The central image here is by JR, who pastes up giant copies of his black-and-white photographs. At first glance, the figure appears to be aiming a gun–but in fact, it is a camera!

Postmodernism is notoriously difficult to define. However, many of the ideas discussed in this book reflect a postmodern approach – the semiotic reading of images as texts, the proposal that reality and identity are 'produced' through language and representations, that the meanings of an image (or text) are not fixed, but open to interpretation and dependent on contexts and beliefs.

The postmodern world is the now familiar one of global communications, digital media and multiculturalism. These developments represent a decisive shift from a 'modernist' world when national and class identities seemed to be more clearly defined and 'fixed', when cultural hierarchies (the distinctions between 'high' and 'popular' culture) were more rigidly asserted, and media communications were passively consumed by a mass audience.

Postmodernism signifies a fluid cultural condition – sometimes this is taken to mean 'anything goes', but really this simply means that assumptions and practices are open to challenge. The recognition that particular discourses, sets of ideas and beliefs, govern specific practices and habits means that they can be demystified, challenged and revised. For many, this represents a liberation (or potential liberation – theory is one thing, practice is another); but, of course, for those who are challenged and who cling to dogmatic rules and beliefs this may be, at best, uncomfortable, and at worst, very threatening.

6.17

6.17

Title: Postmodern dog, 2010

Photographer: Trudie Ballantyne

Photographed near to I.M.Pei's postmodern design for Suzhou Museum (mixing traditional and contemporary design), this dog embodies something of the 'anything goes' spirit of postmodernism. The dog's identity is a collage of styles: a work of art!

Case study
Richard Billingham

Richard Billingham took this photograph of his mother, Liz, in 1995, using out-of-date film in a cheap Instamatic camera. He was then an art student and was taking snapshots of his family to use as reference for his painting.

Take a close reading of the picture and consider the following:

· Is this a good photograph? Is it a work of art?

· If you think it is, what makes it so? If not, why not?

· Consider how the composition of the picture and its aesthetic structure contribute to a reading of the image.

The description of the picture as a 'snapshot' and the motive for making it seems to categorize the picture as 'not art'; indeed, Billingham has stated that at the time of making it, he did not think of it as art.

As a portrait, the picture is unconventional: the point of view, looking down on Liz from above, means that we do not see her face, but the top of her head and her seated body. She is evidently unaware of, or unconcerned about, the taking of the picture; she appears entirely engrossed in the jigsaw in front of her.

The picture falls into two clear parts divided by the horizontal edge of the table. Above, the picture is dominated by the busy floral pattern of Liz's dress and the jumble of jigsaw pieces in her lap. Below, the incomplete jigsaw spreads across the pale brown surface along with a cigarette pack, a drink, and an ashtray.

It is a simple composition, but has astonishing visual richness: Liz's dress and tattoos seem to have been made from the jigsaw pieces she holds; pieces of her life – the cigarette pack (a brilliant blue, which actually announces itself as a piece of sky), the drink (the colour of the table), the ashtray – mingle with the pieces of the jigsaw. All hangs between chaos and order.

Billingham has, whether intuitively, or by design, made a picture of great aesthetic sophistication. Like many of the greatest photographers discussed in this book, he presents us with everyday reality seen afresh, made extraordinary; which is, perhaps, not a bad definition of art.

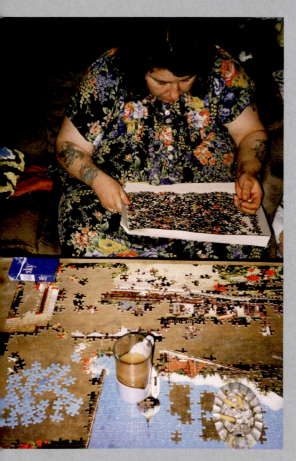

6.18

Title: Untitled, *from Ray's a Laugh*, 1994

Photographer: Richard Billingham (courtesy Anthony Reynolds Gallery)

Billingham's book of photographs of his family, *Ray's a Laugh*, was published in 1996. A family album, of sorts, it presents a disarmingly frank and intimate portrait of his mother, father and brother.

6.18

Synopsis

This case study has looked at how a photograph may be seen as a work of art.

- Photography as art is not necessarily the result of technical sophistication.
- Photography as art is not necessarily dependent upon the photographer's intention.
- The way a photograph frames a piece of reality and makes us see it with new attentiveness can constitute a work of art.

6.19

6.19

Title: Morning sun, 2009

Photographer: Richard Salkeld

The murky atmosphere through which the sun burns is a dirty window! The camera's automated response to being pointed directly at the sun has produced an image that is true to its processing system, but not to natural sight.

Conclusion

In the world of photography today, almost anything is possible: it is perfectly legitimate to cherish the aesthetic principles of modernist straight photography and formal purity, but it is equally legitimate to make full creative use of image-manipulation technology (subject to the ethical criteria of particular practices, such as photojournalism).

Within self-consciously artistic photographic practices, artists may now typically demonstrate a greater awareness of the photograph as a constructed image (rather than a 'pure' transcription of truth and reality). For example, Cindy Sherman's self-portraits, which show the same person represented in a bewildering number of guises, are apparently both truthful representations of her appearance (before the camera) and at the same time representations of performances of fictional identities, thus calling into question not only our faith in the truthfulness of a photographic portrait, but also the very idea of a fixed and representable identity itself (see Chapter 4).

Contemporary practitioners may also demonstrate their awareness of art history by referencing painters such as Edouard Manet (Jeff Wall) Vermeer (Tom Hunter) and Claude Lorrain (Simon Norfolk); many artists have even returned to nineteenth-century methods and processes: Chuck Close makes daguerreotypes, Sally Mann uses the wet collodion process and Vera Lutter uses pinhole cameras.

Artists such as Andreas Gursky and Thomas Struth make wall-sized prints, which can only be experienced in a museum or gallery. Michael Wolf and Thomas Ruff cull images from the Internet; Richard Prince has re-photographed advertisements; Sherrie Levine has even re-photographed photographs by modernist masters, such as Edward Weston! And in 2012, one of the shortlisted artists for one of the UK's most prestigious photography prizes – does not even use a camera. John Stezaker makes photomontages from found imagery.

There has never been a more exciting time for photography than now – the creative possibilities, using old or new technologies, are wider and more accessible than they ever have been; and the opportunities for disseminating images are unprecedented. By the same token, the competition has never been fiercer

General histories of photography

Badger, Gerry (2011) *The Genius of Photography*, London: Quadrille

Hacking, Juliet (2012) *Photography: the Whole Story*, London: Thames & Hudson

Jeffrey, Ian (1981) *Photography: A Concise History*, London: Thames & Hudson

Jeffrey, Ian (2000) *The Photography Book*, London: Phaidon

Marien, Mary Warner (2012) *100 Ideas that Changed Photography*, London: Laurence King

Marien, Mary Warner (2010) *Photography: A Cultural History*, London: Laurence King

Newhall, Beaumont (1984) *The History of Photography: From 1839 to the Present*, New York: Museum of Modern Art

Rosenblum, Naomi (2008) *A World History of Photography*, London: Abbeville Press

Specialist histories, topics and exhibitions

Barnes, Martin (2012) *Shadow Catchers: Camera-less Photography*, London: Merrell

Blanks, Tim (2013) *New Fashion Photography*, Munich: Prestel

Bright, Susan (2011) *Art Photography Now*, London: Thames & Hudson

Brougher, Kerry and Ferguson, Russell (2001) *Open City: Street Photographs Since 1950*, Oxford: MOMA

Bush, Kate et al (2012) *Everything was Moving: Photography from the 60s and 70s*, London: Barbican Gallery

Campany, David (2012) *Art and Photography*, London: Phaidon

Costello, D. and Iversen, M. eds. (2010) *Photography after Conceptual Art*, Oxford: Wiley-Blackwell

Cotton, Charlotte (2009) *The Photograph as Contemporary Art*, London: Thames & Hudson

Derrick, R. and Muir, R. eds. (2004) *Unseen Vogue: the Secret History of Fashion Photography*, London: Little, Brown

Dexter, Emma and Weski, Thomas eds. (2003) *Cruel and Tender: Photography and the Real*, London: Tate

Eskildsen, Ute (2008) *Street & Studio: An Urban History of Photography*, London: Tate

Fineman, Mia (2012) *Faking it: Manipulated Photography before Photoshop*, New Haven: Yale University Press

Greenhough, S. (2007) *The Art of the American Snapshot, 1888–1978*, Princeton: Princeton University Press

Hockney, David (2006) *Secret Knowledge: Rediscovering the Lost Techniques of the Old Masters*, London: Thames & Hudson

Howarth, S. and McLaren, S. (2010) *Street Photography Now*, London: Thames and Hudson Ltd

Ingledew, John (2013) *Photography*, London: Laurence King

Lister, Martin and Giddings, Seth eds. (2010) *The New Media and Technocultures Reader*, London: Routledge

Mellor, David (2007) *No Such Thing as Society: Photography in Britain, 1967–1987*, London: Hayward Publishing

Mora, Gilles (2007) *The Last Photographic Heroes: American Photographers of the Sixties and Seventies*, New York: Abrams

Orvell, Miles (2003) *American Photography*, Oxford: Oxford University Press

Phillips, Sandra S. ed. (2010) *Exposed: Voyeurism, Surveillance and the Camera*, London: Tate

Steichen, Edward (1996) *The Family of Man*, New York: MoMA

Strauss, David Levi (2003) *Between the Eyes: Essays on Photography and Politics*, New York: Aperture

Weiss, Marta and Porta, Venetia (2012) *Light from the Middle East: New Photography*, Göttingen: Steidl

Wells, Liz (2011) *Land Matters: Landscape Photography, Culture and Identity*, London: I.B. Tauris

Westerbeck, Colin and Meyerowitz, Joel (1994) *Bystander: A History of Street Photography*, London: Thames and Hudson

Photography and theory

Barrett, Terry (2000) *Criticizing Photographs: An Introduction to Understanding Images*, Boston: McGraw Hill

Barthes, Roland (2000) *Camera Lucida: Reflections on Photography*, London: Vintage

Barthes, Roland (1984) *Image – Music – Text*, London: Flamingo

Barthes, Roland (1993) *Mythologies*, London: Vintage

Bate, David (2009) *Photography: The Key Concepts*, Oxford: Berg

Baudrillard, Jean (1994) *Simulacra and Simulation*, Ann Arbor: University of Michigan Press

Benjamin, Walter (2009) *One Way Street and Other Writings*, London: Penguin

Berger, John (2008) *Ways of Seeing*, London: Penguin

Berger, John and Mohr, Jean (1995) *Another Way of Telling*, New York: Vintage

Bolton, Richard (1982) *The Contest of Meaning: Critical Histories of Photography*, Cambridge: MITP

Bull, Stephen (2009) *Photography*, London: Routledge

Burgin, Victor (1982) *Thinking Photography*, London: Macmillan

Chandler, Daniel (2007) *Semiotics: the Basics*, Abingdon: Routledge

Clarke, Graham (1979) *The Photograph*, Oxford: Oxford University Press

Crow, David (2003) *Visible Signs: An Introduction to Semiotics in the Visual Arts*, Lausanne: AVA

Debord, Guy (1994) *The Society of the Spectacle*, New York: Zone Books

Edwards, Steve (2006) *Photography: A Very Short Introduction*, Oxford: Oxford University Press

Elkins, James ed. (2007) *Photography Theory*, London: Routledge

Fontcuberta, Joan ed. (2002) *Photography: Crisis of History*, Barcelona: Actar

Hall, Sean (2007) *This Means This, This Means That: A User's Guide to Semiotics*, London: Laurence King

Heiferman, Marvin ed. (2012) *Photography Changes Everything*, New York: Aperture

Jeffrey, Ian (2008) *How to Read a Photograph*, London: Thames & Hudson

La Grange, Ashley (2005) *Basic Critical Theory for Photographers*, Oxford: Focal press

Ritchin, Fred (2008) *After Photography*, London: W.W. Norton

Solomon-Godeau, Abigail (1994) *Photography at the Dock: Essays on Photographic History, Institutions and Practices*, Minneapolis: University of Minnesota Press

Sontag, Susan (1979) *On Photography*, London: Penguin

Squiers, Carol ed. (1999) *Over Exposed: Essays on Contemporary Photography*, New York: New Press

Sturken, Marita and Cartwright, Lisa (2009) *Practices of Looking: An Introduction to Visual Culture*, Oxford: OUP

Szarkowski, John (2007) *The Photographer's Eye*, New York: Museum of Modern Art

Tagg, John (1993) *The Burden of Representation: Essays on Photographies and Histories*, Minneapolis: University of Minnesota Press

Trachtenberg, Alan ed. (1980) *Classic Essays on Photography*, New Haven: Leete's Island Books

Van Gelder and Westgeet, Helen (2011) *Photography Theory in Historical Perspective*, Chichester: Wiley-Blackwell

Wells, Liz ed. (2009) *Photography: A Critical Introduction, 4th ed.*, London: Routledge

Wells, Liz ed. (2002) *The Photography Reader*, London: Routledge

Selected critical writing

Batchen, Geoffrey et al eds. (2012) *Picturing Atrocity: Photography in Crisis*, London: Reaktion Books

Brittain, David ed. (1999) *Creative Camera: Thirty Years of Writing*, Manchester: Manchester University Press

Coleman, A.D. (1995) *Critical Focus*, Tucson: Nazraeli Press

Coleman, A.D. (1998) *Depth of Field: Essays on Photography, Mass Media and Lens Culture*, Albuquerque: Univ. New Mexico Pr.

Coleman, A.D. (1996) *Light Readings: A Photography Critic's Writings*, 1968–1978, Albuquerque: University New Mexico Press

Dyer, Geoff (2007) *The Ongoing Moment*, New York: Vintage Books

Grundberg, Andy (1999) *Crisis of the Real: writings on photography since 1974*, New York: Aperture

Szarkowski, John (1984) *Looking at Photographs: 100 Pictures from the Collection of The Museum of Modern Art*, New York: Museum of Modern Art

Selected photographers

Arbus, Diane (2012) *Diane Arbus: An Aperture Monograph*, New York: Aperture

Avedon, Richard (1993) *In the American West*, New York: Harry N. Abrams

Becher, Bernd and Hilla (2006) *Bernd and Hilla Becher: Life and Work*; by Susanne Langer, London: MIT Press

Billingham, Richard (2000) *Ray's a Laugh*, Zurich: Scalo

Brandt, Bill (2013) *Shadows and Light*, London: Thames and Hudson

Close, Chuck (2006) *A Couple of Ways of Doing Something*, New York: Aperture

diCorcia, Philip-Lorca (2011) *Eleven*, Bologna: Damiani

Eggleston, William (2002) *William Eggleston's Guide*, New York: MoMA

Evans, Walker (2012) *American Photographs*, New York: MoMA

Evans, Walker (1984) *Walker Evans at Work*; by Jerry L. Thompson, London: Thames and Hudson

Frank, Robert (2008) *The Americans*, Göttingen: Steidl

Friedlander, Lee (2008) *Friedlander*; by Peter Galassi, New York: MoMA

Goldin, Nan (2012) *The Ballad of Sexual Dependency*, New York: Aperture

Klein, William (2012) *William Klein: ABC*, London Tate Publishing

Knight, Nick (2009) *Nick Knight*, New York: Collins Design

McCullin, Don (2003) **Don McCullin**, London: Jonathan Cape

McCurry, Steve (2012) **Steve MCurry: the Iconic Photographs**, London: Phaidon

Man Ray (2000) **Man Ray: Photography and its Double**; by Emanuelle de L'Ecotais & Alain Sayag, Berkeley: Gingko Press

Mann, Sally (1993) **Immediate Family**, London: Phaidon

Owens, Bill (1999) **Suburbia**, New York: FotoFolio

Parr, Martin (2009) **The Last Resort**, Stockport: Dewi Lewis

Salgado, Sebastião (1998) **Workers: an Archaeology of the Industrial Age**, London: Phaidon

Sherman, Cindy (1997) **Cindy Sherman: A Retrospective**, London: Thames and Hudson

Stieglitz, Alfred (1998) **Aperture Masters of Photography: Alfred Steiglitz**, New York: Aperture

Strand, Paul (2009) **Sixty Years of Photographs**, by Calvin Tomkins, New York: Aperture

Walker, Tim (2012) **Story Teller**, London: Thames and Hudson

Winogrand, Garry (2013) **Garry Winogrand**; by Leo Rubinfien et al, New Haven: Yale University Press

Selected web sources

Aperture Foundation, **www.aperture.org**

ASX: American Suburb X **www.americansuburbx.com**

British Journal of Photography **www.bjp-online.com**

Chandler, Daniel, 'Notes on the Gaze', Media Communications Study Site **www.aber.ac.uk/media/Documents/gaze**

Dove Evolution **www.youtube.com**

Four and Six, Photo Tampering Throughout History **www.fourandsix.com/photo-tampering-history**

George Eastman House: International Museum of Photography and Film **www.eastmanhouse.org**

Hall, Stuart, 'Representation and the Media' **www.youtube.com**

Harry Ranson Center, The University of Texas at Austin **www.hrc.utexas.edu/collections/photography**

Hungry Eye Magazine **www.hungryeyemagazine.com**

International Center of Photography **www.icp.org**

Lens Culture **www.lensculture.com**

Library of Congress: Prints and Photographs **www.loc.gov/pictures**

Magnum Photos **www.magnumphotos.com**

MCS: Media Communications Study Site **www.users.aber.ac.uk/dgc/media**

p7 '[Photography is] so easy…', P. Graham (2009) *Photography is Easy, Photography is Difficult*, Paul Graham Archive, www.paulgrahamarchive.com

p8 'The illiteracy of…', Benjamin W. (1979) *One way Street*, London: NLB, p256; see also, different translation, Benjamin (2009) p192

p12 'Mo Ti observed…', see Rosenblum (2008) p192

p12 'David Hockney has written…', Hockney (2006)

p14 'Humphry Davy reported', see: Marien (2010) p9

p14 'Shadow Catchers…', see Barnes (2012)

p16 'inscribed by… Francis Bauer…' see: Harry Ransom Center, University of Texas at Austin: The first photograph, www.hrc.utexas.edu

p16 'mirror with a memory', O.W. Holmes, in Trachtenberg (1980) p74

p24 'optical unconscious', Benjamin (2009) p176

p24 'It is possible… to describe…', Wells (2009) p19; see also, different translation, Benjamin (2009) p176

p28 'In 1936, Walter Benjamin argued…: ' *The Work of Art in the Age of Mechanical Reproduction*' in Benjamin (2009) pp228–259

p28 'photography… can bring out…', Benjamin, W (1968) 'Illuminations', New York: Schocken Books, p220; see also, different translation, Benjamin (2009) p232

p28 'When the camera…', Berger (2008) p19

p30 'calls for no manipulation…' Trachtenberg (1980) p19

p30 'according to…', Gernsheim, H. (1982) *The Origins of Photography*, NY; Thames & Hudson, p106

p30 'sales of pictures…', Rosenblum (2008) p63

p32 'as Sarah Kennel has shown…', in Greenhough (2007) pp94–7

p33 'argued by…', J. Williamson (1988) 'Family, Education, Photography' in *Consuming Passions*, London: Marion Boyars, pp118–9

p40 'in some respects …', Campany (2003) p150

p41 'according to critic…', Lyle Rexer (2000) 'Chuck Close: Daguerreotypes', *Aperture*, No,160, pp40–1

p41 (caption) 'In 1840, virtually…', Artists & Alchemists, A&A Portrait: Chuck Close, www.artistsandalchemists.com

p50 'Roland Barthes showed…', Barthes (2009)

p56 'polysemy', Barthes (1993) pp32–51 ('Rhetoric of the Image')

p61 'analysis of a Paris Match', Barthes (2009) pp116–8; see also D. Chandler (nd) Semiotics for Beginners, users.aber.ac.uk/dgc/Documents/S4B/sem06

p61 'You cannot learn…', S. Hall (1977) quoted in D. Hebdige (1979) *Subculture: The Meaning of Style*, London: Routledge, p11

p61 'to see through appearances…', D. Hebdige, ibid, p11

p62 'The Death of the Author', Barthes (1993b) pp142–8

p64 '…defamiliarization' or 'making strange'…', see, e.g. C. Raine (2008) 'Making Strange', *The Guardian*, 26 January, www.guardian.co.uk

p66 he saw Simon and Andrew…' The Holy Bible, St Mark, 1:12

p74 'the meaning of an event…' S. Hall (nd) *Representation* & *The Media*, 'www.youtube.com

p80 'All photographs are fictions…', A.D. Coleman (1976) *Theater of the Mind: Arthur Tress*, NY: Morgan & Morgan

p81 'Self-Portrait as a Drowned Man, inscribed…', Gernsheim (1982) op cit, p69

p81 'seen as a violation…', S.F. Eisenman (2011) *Nineteenth Century Art: A Critical History*, London: Thames & Hudson, p295

p82 'the 'directorial mode'…', Coleman (1996) pp246–57

p85 Brian Walski, see Photo Tampering throughout history, www.fourandsix.com

p86 '… a kind of insanity…', C. Jacobson (2010) 'Shaped by War: Don McCullin in profile', *British Journal of Photography*, 3 March, www.bjp-online.com

p86 (caption) ' if your pictures…', R. Capa, see eg, Marien (2010) p307

p86 'all of life presents…', ibid, p12

p87 Debord (1994) p12

p87 'simulation' and 'hyperreality', see, e.g. J Baudrillard (1983) *Simulations*, Cambridge: MITP

p87 'loss of the real', ibid

p88 'I believe that street photography…', J. Meyerowitz, in Coleman (1998) p160

p90 'how could this group…', T. Hoepker (2006) 'I took that 9/11 photo', Slate.com, www.slate.com

p93 'an almost idyllic scene…', ibid.

p93 'A snapshot can make…', W. Sipser, 'It's me in that 9/11 Photo', Slate.com, www.slate.com

p95 'If you want to know …', A. Warhol (1967) in K. McShine ed. (1989) *Andy Warhol: A Retrospective*, NY: MoMA, p457

p95 'It is only shallow people…', O Wilde (1992) *The Picture of Dorian Gray*, Ware: Wordsworth Editions, p21

p96 'I would willingly exchange…', G.B. Shaw, attrib.

p96 'Don't try to capture…' A. Rodchenko (1928) quoted by A. Solomon-Godeau in Bolton (1982) p87

p97 'I happened on a photograph…', Barthes (1993a) p3

p105 'a natural portrait', R Dijkstra (2008) 'A conversation with Rineke Dijkstra', Pop Photo.com, www.popphoto.com

p106 'the eyes of them…, The Holy Bible, Genesis 4:7

p106 Chandler, D, Notes on the Gaze, www.aber.ac.uk

p108 'One is not born…', S. de Beauvoir (2010) *The Second Sex*, London: Vintage, p293

p108 'Men act and women appear…', Berger (2008) p47

p113 Dove 'Evolution', www.youtube.com

p114 'The work deals with reality…', J Bieber (2010) 'Real Beauty', Visura Magazine.com www.visuramagazine.com

p117 (caption) 'make more women…', Dove, www.dove.co.uk

p120 'the image speaks for itself', M. Garanger, New York Photo Festival, 2010, www.youtube.com

p123 'Stare. It is the way…' W. Evans, in Phillips (2010) p22

p123 'It is a short leap…', M. Rush (2004) 'Security Art', PAJ: A Journal of Performance and Art, Vol26, No1, p113

p124 'So outraged were the…', Tagg (1993) p105

p127 'were each mounted…', Tagg (1993) p74

p130 'popular sciences of phrenology…', M. Henning, in Wells (2009) p177

p132 'A stupid despot…', M. Foucault (1995) *Discipline and Punish*, London: Vintage p102

p134 'For a long time ordinary…' M. Foucault (1995) ibid, p191

p134 'We cannot blame…', Phillips (2010) p11

p136 'naked repose', 'the guard is down…', 'apologetic voyeur', W. Evans in J.L. Thompson

p136 'I'm not sure I would like it…', P. diCorcia (2010), 'Exposed', Tate: Channel, www.tate.org.uk

p138 (caption) 'they love each other…', I. Popova, www.irinapopova.photoshelter.com

p139 'We see things…', A. Searle (2003) 'Crime scene investigator', *The Guardian*, 22 July, www.guardian.co.uk

p139 'degradation and despair…', B. Morrison (2012) 'Irina Popova's photographs…', *The Guardian*, 15 June, www.guardian.co.uk

p140 'Geoff Dyer has noted…', G. Dyer (2012) 'How Google Street View is inspiring new photography', *The Observer*, 14 July, www.guardian.co.uk

p142 'it was important for me…', S. Yokimozo (2010) 'What are you looking at?' Tate Etc, Issue 19, Summer, www.tate.org.uk

p144 (caption); When I developed…', S. Roesink, *The Guardian*, 31 July 2011 www.guardian.co.uk

p146 (caption) 'symbolically guides…', Marien (2010) p283

p147 'art has become…', Campany (2003) p14

p148 'Scruton has argued…'. R. Scruton (1989) 'But is it Art?', *Modern Painters*, Vol. 2, No1, Spring, pp62–5; see also R. Scruton in A. Neill (2001) *Arguing About Art*, London: Routledge, pp195–1214

p149 'A photograph is never…' R. Scruton (1989) op cit, p62

p151 'I photograph things…', G. Winogrand, in Howarth (2010) p11

p155 'He took an article…', see S. Howarth (2000) Tate [Gallery collection] www.tate.org.uk

p158 'We have sufficient…', Fox Talbot in H Honour (2005) *A World History of Art*, London: Laurence King, p661

p163 Szarkowski (2007) pp8–11

p164 'can endow any soup…' Benjamin W. (1979) *One way Street*, London: NLB, p255; see also, different translation, Benjamin (2009) p190

p168 'For every photographer…' N. Foote in D. Fogle ed. (2003) *The Last Picture Show*, Minneapolis: Walker Art Center, p24

p169 'Someone like Bill Brandt…', A. Bowness (1982) in D. Brittain ed. (1999) *Creative Camera: Thirty Years of Writing*, Manchester: Manchester U. P., p66

p169 'it might be said…' J. Szarkowski (1984) *Looking at Photographs*, NY: MoMA, p120

Picture credits

The publishers would like to thank all the photographers who contributed work to this book.

p3: courtesy of Richard Salkeld

p7: courtesy of Erik Kessels/photo by Gijs van den Berg

p10: © Jeff Wall, 'Picture for Women', 1979, transparency in lightbox, 142.5x204.5cm. Courtesy of the artist

p13: Fotosearch/Getty Images; Fine Art Images/Getty Images

p15: courtesy of Lisa Lavery

p19: SSPL via Getty Images

p21: courtesy of Richard Salkeld

p23: Time & Life Pictures/Getty Images

p25: Cocoon/Getty Images

p27: SSPL via Getty Images

p29: Henri Cartier-Bresson/Magnum Photos; The Bridgeman Art Library/Getty Images

p35: Martin Parr/Magnum Photos

p36: Jacob A. Riis/Getty Images

p37: courtesy of Joanna Casey

p38: Maciej Toporowicz, NYC/Getty Images

p41 and **p43:** photography by Chuck Close in collaboration with Jerry Spagnoli, courtesy of The Pace Gallery. © Chuck Close, The Pace Gallery

p44: courtesy of John Ingledew

p46: Atlaspix/Shutterstock.com; courtesy of Trudie Ballantyne

p48: courtesy of Trudie Ballantyne

p49: courtesy of Joanna Casey

p50: courtesy of Emilia Nylén

p51: Elliott Erwitt/Magnum Photos

p52: courtesy of Richard Salkeld

p54: Peter Marlow/Magnum Photos

p57: Jim Goldberg/Magnum Photos

p59: courtesy of Bill Owens Archive

p59: H. Armstrong Jones/Retrofile/Getty Images

p60: IZIS/Paris Match via Getty Images

p63: courtesy of Richard Salkeld

p64: courtesy of Trudie Ballantyne

p65: Chris Ratcliffe/Bloomberg via Getty Images

p67: courtesy of Anthony Barrett

p68: Martin Parr/Magnum Photos

p71: Warner Bothers/Getty Images

p72: Eddie Adams/Press Association

p75: 1000 Words/Shutterstock.com

p76: courtesy of Joanna Casey

p78: Jacob A. Riis/Museum of the City of New York/Getty Images

p79: courtesy of Matt Frederick

p80: Christopher Anderson/Magnum Photos

p82: © Gregory Crewsdon. Courtesy Gagosian Gallery

p83: © Jeff Wall 'Dead Troops Talk' transparency in lightbox 229x417cm. Courtesy of the artist

p84: RIA-NOVOSTI/AFP/Getty Images

p86: Robert Capa © International Centre of Photography/Magnum Photos

p87: courtesy of Alex Bland

p89: Bruce Gilden/Magnum Photos

p91: Thomas Hoepker/Magnum Photos

p93: Spencer Platt/Getty Images

p94: Daniel Acker/Bloomberg/Getty Images

p98: Kenneth Benjamin Reed/shutterstock.com

p100–101: © Roy Villevoye. Courtesy of Motive Gallery, Brussels (BE)

p103: © T. Dworzak Collection/Magnum Photos

p104: Steve McCurry/Magnum Photos

p107, 109 and **111:** courtesy of Joanna Casey

p112: courtesy of Elizabeth Ayre

p115: Nicholas Bailey/Rex Features; courtesy of Nicola Fordyce

p116: Baron de Meyer/Mary Evans/National Magazines; Christopher Anderson/Magnum Photos

p119–121: courtesy of Marc Garanger

p122: VUFKU/The Kobal Collection

p129: Eadweard J. Muybridge/George Eastman House/Getty Images add J to caption

p133: Mansell/Time & Life Pictures/Getty Images

p135: April Smith

p137: Bruce Davidson/Magnum Photos

p137: courtesy of Vicki Haines

p138: courtesy of Irina Popova

p141: Harold Cunningham/Getty Images

p143: courtesy of Shizuka Yokomiza

p144: © Sarah Roesink

p147: Jorma Puranen, courtesy Purdy Hicks Gallery

p149: courtesy of Richard Salkeld

p151: Alec Soth/Magnum Photos

p153: courtesy of Richard Salkeld

p154: John Stezaker, courtesy of The Approach, London

p159: Robert Demachy/SSPL/Getty Images

p162: Inge Morath/© The Inge Morath Foundation/Magnum Photos

p165: courtesy of Richard Salkeld

p167: © Ed Ruschka. Courtesy Gagosian Gallery

p168: Photofusion/Universal Images Group via Getty Images

p171: courtesy of Trudie Ballantyne

p173: Richard Billingham, courtesy Anthony Reynolds Gallery

p174: courtesy of Richard Salkeld

Thanks to colleagues at the Centre for Art & Photography, University of Gloucestershire, and especially to: Trudie Ballantyne, Richard Billingham, Matt Frederick, John Ingledew, Lisa Lavery, and Nick Sargeant; thanks to students past and present, and especially Lizzie Ayre, Alex Bland, Joanna Casey, Nicola Fordyce, Vicki Haines, Emilia Nylén, and April Smith; thanks to my editors at AVA/Bloomsbury: Georgia Kennedy, Jacqui Sayers and Kate Duffy; thanks to all those photographers who have contributed their images. Special thanks to Sarah Madley for all her support and to whom this book is dedicated.